// Webworks
Advertising

ROCKPORT

First published in the United States of America
by Rockport Publishers, Inc.
33 Commercial Street
Gloucester, Massachusetts 01930-5089
Telephone: (978) 282-9590
Facsimile: (978) 283-2742
www.rockpub.com

ISBN 1-56496-564-3

10 9 8 7 6 5 4 3 2 1

Design: Otherwise, Inc.

Printed in China.

// Webworks

Advertising

GLOUCESTER MASSACHUSETTS

ROCKPORT PUBLISHERS

Thom.Forbes

Table of Contents

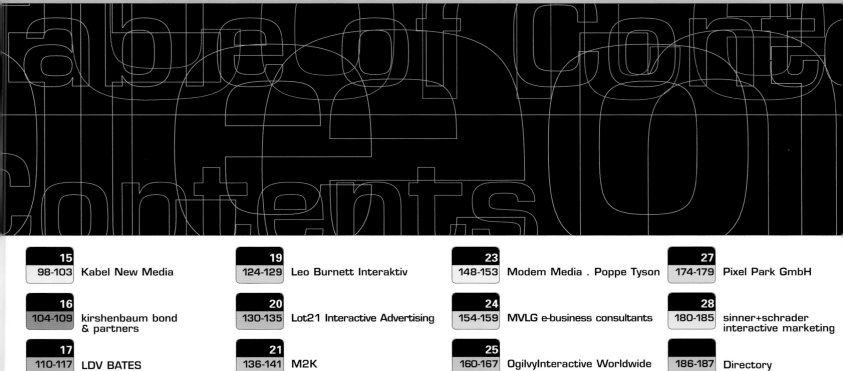

Foreword
by Andrew Jaffe

>> The first thing about Web design we all need to learn—or re-learn—is that even though the Web is something completely new and wonderful, communication isn't. That sounds pretty obvious, but you'd be surprised how few Web designers have fully absorbed this simple truth. As a result, a lot of what's going on today on Web sites is downright silly or—worse—confusing, misleading, and hurtful to the brands they represent.

Designers will tell you the first thing they do with a new client is try to "understand the brand." But sometimes the client may not be the best person to answer that deceptively simple line of inquiry because while clients "own" the brand and probably have the trademark hanging on the wall, they don't possess it. Brands are ephemeral rascals that only exist in people's hearts and minds.

Take my Honda CRV. It's a wonderful vehicle that in two years of ownership has never broken down or coughed or required a tune-up. As a result I'm as passionate about it as someone driving a Range Rover or bulky Navigator at three or four times its price. So I have begun projecting, as psychiatrists say, my feelings about my truck onto the brand—describing it as if it were a person or friend who is "reliable," "ready to go," "pretty good looking," "hearty." I also attribute many of these characteristics to the people who build and maintain the CRV. This may be rubbish, considering that I know very little about automobile engineering and have never visited a Honda factory or met anyone connected with Honda other than the dealer who sold me the car and one of his mechanics. But as a consumer, the positive attributes I attach to my truck also extend to the brand and everyone associated with it.

When you start playing around with brands, you find they are most powerful critters indeed. Follow a brand onto the Web and see what happens. The first thing you'll find is that the techie who designed the Web site was probably in a hurry to make it up-to-date with the latest technology. He or she may have activated the site with Java and Flash and streaming video and audio. Games are offered on the site or on ad banners leading to it, as well as prizes, treasure hunts, little movies or icons to be downloaded, pieces of music or sounds, and so on. However, the ordinary user of the brand may not be interested in flashy interactions, but really wants an experience much like driving the CRV—boring but dependable.

So before getting too excited about designing new sites for the Web, we need to go back and discover what is so compelling about commercial communications in the offline world. What makes that little Chihuahua with the funny attitude such a charming salesdog for Taco Bell? Why does a picture of Albert Einstein or Maria Callas make us inclined to buy a Macintosh PC? In some ways, communication on the Web is no different than other communication; we, the audience for communication, haven't changed much in the last 50 years. However, the media by which we receive data and information has changed.

I've had the opportunity to look at Red Sky's Interactive CD-ROM prototype for what their Web site might look like in two years. You meet a cowboy named Gus Gilroy who welcomes you to the Red Sky corral. He lets you play around with your cursor until it becomes a pistol that allows you to shoot various icons in the corral as you look for a dangerous varmint called Dirty Dan.

01 02 03 04 05 06 07 08 09 10 11 12 13 14

Now why would a company as capable as Red Sky construct a graphical interface that looks like the set of a 1950 cowboy movie—in black and white no less—in order to begin a dialogue with sophisticated marketers like Lands' End, Absolut Vodka, Nike, and Procter & Gamble? Tim Smith and his colleagues at Red Sky have never lost sight of the fact that their first job is simply to welcome you to their corral and entertain you—and for that there is no reason to create new formats and ideas. In fact, they're a lot better off drawing on familiar images associated with their brand.

Even for the most advanced techies, the Web can still be an intimidating encounter. There are millions of Web sites out there, all accessible with a flick of the wrist. That's an experience mankind has never had before. The closest we've come, I suppose, is the telephone, which enables you to call anyone almost anywhere in the world. But the protocols of telephony are not nearly as fast or as easy as the Internet. Now you're able to zap through cyberspace with virtually no introduction or delay and begin talking to people and companies you don't even know. And you can do it all without divulging your identity.

At first, the Web seems so vast it's hard to comprehend. When users get accustomed to moving about in it, they pitch up on someone's doorstep and begin asking questions or looking for something on the Web site. That provides Web techies another set of potential interactions with the visitor, and communication rapidly gets much more complex. Should the brand say hello, or should it ask some information of the visitor, or simply give the visitor a map and let him or her roam at will through the site? After segmenting the visitor according to purpose or address, then what? Should the brand deliver an experience consistent with the qualities of the brand that have been established in the physical world, or should the brand begin to provide a different experience for the visitor—and with what anticipated result?

Trying to provide guidance for advanced Web design involves complex questions; before we know it, we're lost in a quagmire of our own making. But after four years of hosting and attending conferences about Internet advertising and commerce all over the world, after endless sessions with fellow publishers, editors, and information specialists on the board of the Internet Content Coalition, after writing and lecturing about marketing on the Web, I've learned one lesson: it's still just another form of human interaction enabled—and sometimes disabled—by technology.

The Web is not only a very young medium, it's also still very crude. Most computers can't download and view 30 frames a second without delay; therefore, transmitting any kind of animated communication is still pretty difficult. The resolution of an image on your computer screen doesn't yet approach that of looking at an ad in a copy of *Men's Journal*, making it challenging to deliver images with the clarity and excitement of print. But we're getting there. The pioneers of this magic new medium—the agencies selected to showcase their work in this fascinating book—are beginning to carve out certain principles and basics of the art of interactive design that will serve us well as we develop more bandwidth, widen the pipeline, and allow more interesting, vibrant kinds of communication through the Web.

As my good friend Tim Smith would say: "Understand physics, but believe in magic."

Andrew Jaffe is executive director of the Clio Awards and publishing director of Adweek Books. He was founder of the Adweek Forum at Internet World Expo, executive director of @d:Tech and a founding member of the Internet Content Coalition.

Introduction

by Thom Forbes

>> Creative tension probably dates back to when our ancestors were hunting woolly mammoths. I imagine a hunter scratching on the wall of the communal cave a representation of the beast he has just slain. A primordial creative director sidles up and suggests that he move the pictograph down six finger lengths, make the outline a little bolder, and smudge it all with some indigo. And guess what? Sometimes—not always, but often—the creative director's carping would actually improve the artist/hunter's work.

Creative tension permeates advertising. Art director and copywriter thrash out a concept, leaving blood on the floor. The executive creative director picks apart the resulting execution and puts it back together again, tauter and clearer. A few accommodations are made at the behest of Nervous Nellie, the account supervisor whose mortgage payments depend on knowing just how far the client can be pushed. Finally, there's the do-or-die struggle to get the tamer but still clutter-busting work past the Guardians of the Hallowed Brand at corporate headquarters. Less often than is desirable (but immediately recognizable when it happens), a brilliant piece of informative, entertaining, and effective advertising emerges from all this turmoil. Advertising that informs. That evokes laughter, tears, or nods of empathy. That sells.

Interactivity has introduced a new player into the drama of creating advertising, and she's stealing the show. She's the consumer. The interactive consumer is the embodiment of creative tension, a mixture of experience and passion ferociously expressed. She knows what she likes—whether intuitively or rationally—and will not hesitate to act on her desires. The interactive consumer will also fail to act on her desires; indeed, that is what she does most often. The click rate on most banner advertising is less than one percent and steadily declining. But in the pages that follow, you'll find Web advertising that has been remarkably successful, whether the measure is click rates, branding, or sales. Because Web advertising is interactive and measurable, creatives know almost immediately which executions are effective, and which are not. Colors can be changed immediately. Typefaces altered. Elements shifted on the page. Ineffective copy lines tweaked, or dropped.

Although consumers have had a say in how ads are crafted—through copy testing and focus groups—for decades, those are artificial environments. There is nothing artificial about e-commerce through the Internet. And advertising, in forms that will undoubtedly evolve from the fin de millennium samples you find here, will surely play a major role in making the Web the dominant

01 02 03 04 05 06 07 08 09 10 11 12 13 14

source for marketing information and transactions in the 21st century. If you readers of this book are who I think you are, you'll be firmly at the reins of the evolution—harnessed to the driving force of the consumer.

The creators of interactive advertising in this book represent a wide array of styles and philosophies. They range from techno-boutiques thrown together by self-described geeks to divisions of the most august mainstream advertising agencies. All share the understanding that "the user is in control on the Web," as Erwin Jansen, interactive managing director of LDV BATES points out. On the Web, it's much easier to determine exactly what the user likes and dislikes—what makes her accept or reject a sales proposition, read more about a product or click to a competitor's site. "You can't put a camera behind somebody's eyes and know how they really read an ad, or know how they really look at a television commercial," says iDeutsch's Adam Levine. "But the click of a mouse tells you a shitload."

Many verities of design remain true on the Web, but some new rules are being written, too. They're not like the old saws of print, handed down by geniuses like Ogilvy and Bernbach, who ruled their agencies through intuitive points of view. The new rules are being served up by the consumer.

The folks at sinner+schrader interactive marketing will tell you that the funnier a banner is, the shorter its life should be. That's because they've quantified that funny banners generate high click rates, but only for a short time. Because users laugh at a joke only once, sinner+schrader changes some very effective banners after a mere week's run on the Web.

Historian Daniel J. Boorstin points out that people in democratic societies talk to each other in the language of persuasion. It's how we try to convince each other that our ideas—and products—are better than the other guy's. Many persuasive ideas are expressed in this book. Freestyle Interactive tells us that the GIF banner is dead and that rich media is the future of interactive advertising; Brand Dialogue cleverly makes the point with some mock porn banners that you need to aim for the heart, not the eye. There's no right and wrong here. The whole industry is learning. This book offers a smorgasbord of approaches to a craft that's taking its first baby steps. Great advertising sells, no matter what form it takes. And what sells—from a design and copy standpoint—will become clearer and clearer as you creatives delve deeper into the interactive magic of this medium.

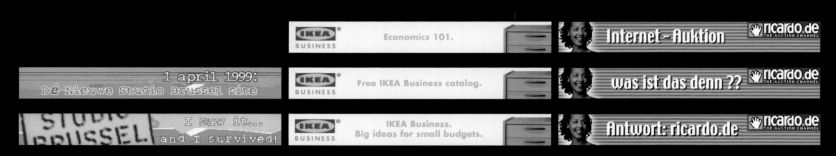

>> **LDV Bates**—This banner for Studio Brussel, the top youth radio station in Belgium, ran only on the launch date of its Web site and was downloaded thousands of times as a collector's item.

>> **iDeutsch**—This three-frame animated GIF banner for IKEA promotes a free brochure for businesses and home-office workers in need of furnishings.

>> **sinner+schrader**—Promising fun and entertainment in an effort to make the brand likeable, a series of banners feature a broad variety of smiling faces that ask questions such as, "Online auctions, what's that?"

>> In and of itself, a banner advertisement may never sell the likes of an automobile. Nonetheless, you'll find a lot of advertising for automobiles here. Mercedes, BMW, Peugeot, and all the other automakers have extensive Web presences through which they brand and build relationships.

"Interactive provides something you can't buy in any other medium, and that's the ability to interact with, and around, the brand," says Tom Beeby, creative director at Modem Media . Poppe Tyson. "You can demonstrate for yourself the relevance of that brand in your life." Banner advertising clearly has its place in this mix. Sprinkled around the Web in appropriate spots, banners for automakers are like the calling cards that ladies and gentlemen left behind them when they called at finer residences of the last century. "Here's how to get in touch with us, if you'd like," they say.

If that analogy sounds a bit highfalutin, let's not forget that the Internet itself is highfalutin. To marketers, the Net represents a virtual gold mine of educated, affluent consumers who not only have the ability to talk back but are extremely articulate when they do so. Globally, they are the crème de la crème of sophisticated consumers. That's why it's so critical to respect their time and intelligence. "Design should not try so hard, and not say too much," says Peter Jin Hong, creative director at Palmer Jarvis DDB Interactive. "We

are given a privilege of being in the audience's personal space. Hence, we should be brief, entertaining, natural, and say it with sincerity."

I just asserted that banner ads can't sell automobiles. But I can envision a banner where you type in a particular make and model and get back price quotes from a dozen dealers almost instantaneously, similar to the way that the John Hancock Portrait Planning Tool offers financial information (see page 152). If such an ad existed a few weeks ago, I might have leased my new van from a different dealer. If a banner existed that analyzed several makes and models and made a recommendation, I might have purchased instead of leased, or gone to a different nameplate entirely. Just thinking about the schemes and possibilities that Web advertisers are no doubt developing fires up the inclination to begin typing my credit card number in a shopping-cart form. But first we need to establish a relationship. Please let me know what you're creating by e-mailing me at tforbes@tforbes.com.

>> **Brand Dialogue**—Users follow the footsteps of a polar bear from the Langnese ice cream print campaign through the banner and onto the Web site.

>>**Modem Media . Poppe Tyson**—Designers felt that to be effective, they could only use two fields to gather data. They worked with John Hancock to limit the required data-entry points accordingly.

>> **Palmer Jarvis DDB**—From frame to frame, there is a purposeful, rhythmic coordination to the flow and order of information, much like a strong bass beat keeps other instruments synchronized.

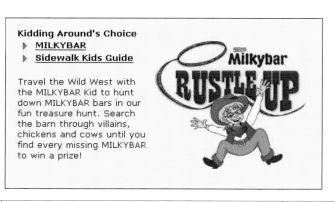

>> To promote Nestle's MILKYBAR, APL Digital conceived and built the MILKYBAR 'Rustle Up' online game, which was promoted via sponsorship of the Nine MSN 'Kidding Around' chat room.

>> A screen shot from a flash presentation about APL Digital.

Building Powerful Online Brands

> *"Inspired creativity. Brilliantly executed." -Martin Puris*

> *Online advertising should not just grab your attention; it should keep your attention by providing a meaningful, interactive brand experience.*

> *Online advertising creative must think outside the rectangle and provoke a Net result.*

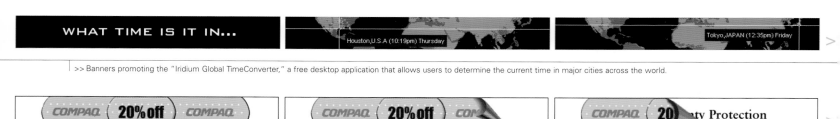

>> Banners promoting the "Iridium Global TimeConverter," a free desktop application that allows users to determine the current time in major cities across the world.

>> APL Digital uses metaphors for protection, repair, and specialty care in this launch campaign for Compaq's CarePaq services.

01 02 03 04 05 06 07 08 09 10 11 12 13 14

APL Digital Sydney

APL Digital Sydney was established in September, 1995, as a joint venture between technology marketing company Marketing Resources Management (MRM), and the global, full-service advertising and communications agency, Ammirati Puris Lintas (APL). It believes the Internet industry allows the development of a new business model that moves beyond traditional relationships between staff, clients, and suppliers. The agency has produced interactive products for some of Australia's best-loved brands.

APL Digital views design as a strategic function. As a full-service interactive agency developing Internet business solutions for clients in a wide variety of industries and competitive climates, it carefully analyzes the business imperatives for all its clients' projects. From developing corporate Internet business re-engineering solutions to creating consumer brand-building banner advertisements, the agency believes a thorough understanding of the reason for the interactive initiative is essential to success.

With its relationship to Ammirati Puris Lintas, APL Digital is expert in developing branding solutions for the online medium. Because the Web can provide consumers with the most direct interactive experience with a brand available, APL Digital's analysis of the imperatives of an online project involves exploring the brand's target audience, values, promise, and personality. It adopts the role of "online brand custodians" for its clients, developing a creative advertising design that reinforces and enhances the brand, is eye-catching, and contains a strong call to action.

"Outstanding Web advertising executions enhance the emotional interaction between the brand and the consumer. It is their emotional response that motivates a viewer to interact and has a direct effect on recall and brand building," says APL Digital art director Matthew Chapman.

APL Digital does not reproduce print advertisements for the online environment; it strives to create powerful interactive brand experiences. Developing innovative online executions involves a careful balance between making the most of emerging technologies and optimizing the client's return on investment. As technologies converge and develop, the stories marketers and advertisers can tell become richer and more involving.

"The power to create powerful, emotional brand experiences and respond to individual user queries using imagery, animation, sound, and complex database interactivity is an exciting thing for the consumer, the brand, and us as designers," says Chapman.

Designers producing interactive advertising must also consider the climate of the medium. APL Digital feels the trend towards lower click-through rates on banner advertising is an indication of Web users' coming of age. Experienced users need a compelling reason to click on an ad. Web designers also face the challenge of achieving maximum impact within the smallest file size. According to Chapman, this forces designers to really think about the function and effectiveness of graphic design, animation, sound, and communication. "As opposed to print, TV, and other media, the Internet has the advantage of allowing rapid changes to creatives. If an online execution isn't working, it's relatively easy to track why and fix it," says Chapman. While interactive advertising designers must address an array of business, brand, technology, and market imperatives, APL Digital always strives to achieve the greatest possible return on their clients' investment through "inspired creativity14
, brilliantly executed."

An autonomous subsidiary of Ammirati Puris Lintas / **Address.**Level 7, 65 Berry Street, North Sydney NSW 2060 Australia / **Voice.**+61 2 9925 1333 / **Fax.**+61 2 9954 3055 / **E-mail**.contact@apldigital.com.au / **Web Site**.apldigital.com.au / **Executives.**Gary Henstridge.Chief Executive Officer, Andrew Gardner.Managing Director

13

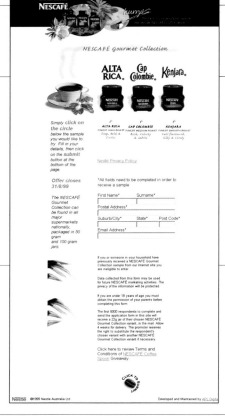

>> The initial banners for the campaign reinforce the brand's premium identity.

>>

>>

>> Because click-throughs were lower than expected, executions containing a much stronger call to action replaced the initial banners shortly after launch.

>> All the banners click-through to a catch mini-site where users submit information via an animated, online form to request a free Nescafé Gourmet coffee sample.

01 02 03 04 05 06 07 08 09 10 11 12 13 14

Marketing Objective:

To expose the product to a broad demographic of discerning coffee drinkers. The campaign won "Best Direct Marketing/Promotions Campaign" at the inaugural 1998 Yahoo! and AdNews Internet Awards for best utilizing the online medium to solicit required feedback from customers or potential customers.

Creative Strategy:

To reinforce the brand's premium identity while incorporating visuals from the existing print campaign. The banner creative contains a strong call to action, directing click-throughs to an animated catch site where users provide details via an online form to request their coffee sample.

Media Placement:

The initial campaign ran for four months (from July 1998 through October 1998) on three Australian portal sites and two popular Australian complementary industry sites.

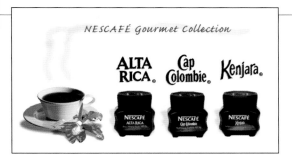 >> 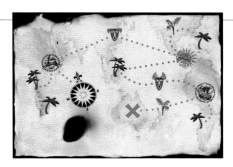 >>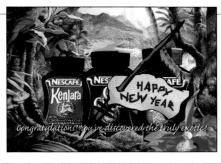

>> As a follow-up communication to keep the brand experience fresh in consumers' minds, the Nescafé Interactive Treasure Map is e-mailed as an attachment to sample recipients.

Account Manager.Susie Dalton / **Account Manager.**Geoff Rapp / **Producer.**Brett Rolfe / **Producer.**Steen Andersson / **Graphic Designer.**Natalie Brown / **Graphic Designer.**Andrew Turner
Tools Used.Adobe Photoshop / Macromedia Fireworks

>> Yates Problem Solver Banner Campaign

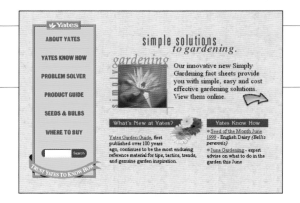

>> APL Digital developed separate Web sites in Australia and New
Zealand for Arthur Yates & Co. Ltd., the largest manufacturer and
marketer of garden products in both countries.

>> The banners visually demonstrate a common garden problem and its cause.

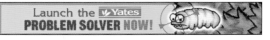

>> Clicking provides an immediate solution through the Yates Garden
Problem Solver application.

Account Managers.Susie Dalton / **Account Managers.**Geoff Rapp / **Producer.**Jeni Rowland / **Art Director.**Matthew Chapman
Tools Used.Adobe Photoshop / Macromedia Fireworks

01 02 03 04 05 06 07 08 09 10 11 12 13 14

Marketing Objective:

Build the brand by re-establishing a direct relationship between the company and its customers that was lost in 1927 when it began distributing through retail stores.

Creative Strategy:

Push the message "Yates Know How" and position Yates as providing expert gardening advice online through quirky and eye-catching creative.

Media Placement:

Ran on Yahoo! Australia from September 12 through December 20, 1998 in a broad buy incorporating run of site, one category, and a number of keywords (on certain keywords, the banners achieved a staggeringly high average click-through rate of 32.56%).

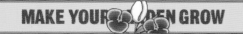

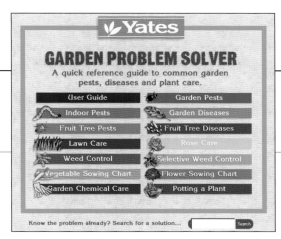

>> This execution demonstrates the colorful benefits of Yates' gardening "Know How."

>> The Problem Solver application launches in a self-contained browser window.

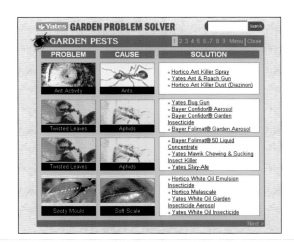

Building Brands and Driving Traffic

> *People remember what they interact with.*

> *Less is more.*

> *You can only determine the value of your creative work by the results you've gained for your clients.*

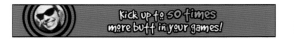

>> Banners for MediaOne Express appeal to gamers.

Beyond Interactive

CEO Jonn Behrman of Beyond Interactive launched Wolverine Web Productions from his apartment in 1995 while attending the University of Michigan. The company has grown to more than 60 associates in three U.S. offices and acquired a new name. It offers full-service online advertising solutions, from strategic planning to media planning and buying, banner design, third-party ad serving, and campaign management and optimization.

Beyond Interactive believes that an online advertising campaign is like a jigsaw puzzle with three pieces:
- Strategy, which is the overall plan for accomplishing goals on the Web;
- Media, which is the placement strategy come to life;
- Design, which represents the physical and visual aspect of the strategy.

All three elements must be in place for the puzzle to be complete. As important as media placement is to success, users don't stop to admire an excellent media buy. What they do notice, and click on, is the physical aspect of the strategy—the design. Beyond Interactive believes that design is as crucial to successful online advertising campaigns as the media plan.

"Good design is imperative, because it bridges the gap between the advertiser and the customer," says Behrman. "If a visitor doesn't notice the ad, the ad has not accomplished anything. Good design gets attention and interaction, and indicates that the campaign's strategy is effective."

Although campaigns achieve success through different means, some key elements remain constant. Banners must grab attention with attractive design combined with a clear, simple message that is communicated quickly, often with a specific call to action. Beyond Interactive's creative team always keeps the goal of the campaign in mind—whether it's branding benefits or direct marketing—to determine how the design and copy can best achieve results.

As Web marketing strategies evolve, elements such as interactivity and permission marketing have come into play. This has led to new advertising techniques like rich media banners using HTML, Flash, and JavaScript. "When the design and copy on a banner is presented in such a way that users are compelled to enter their e-mail address," says Behrman, "they are in effect saying 'Yes, I want to find out more, I'm willing to receive more messages about this product or service, and here's the place to send it.' "

Banners now offer creative and powerful incentives to click, like scratch-off cards that can lead to instant prizes. In these cases, the design has more to do with reinforcing functionality and activity than with aesthetics. Beyond Interactive is also integrating more creative types of design, such as Flash animation and promotional tie-ins, into campaigns. The methods of design may change as the Web advertising industry evolves, Behrman says, but the principles that make it effective will not.

>> A straightforward call to action for Ford Rent-A-Car.

>> A simple, clear enticement for AutoNation USA.

Address.5075 Venture Drive, Suite B, Ann Arbor MI 48108 / **Voice.**734 747 8619 / **Web Site.**www.gobeyond.com / **E-mail.**manager@gobeyond.com / **Executives.**Jonn Behrman.Chief Executive Officer

>> This banner (one of the first that ran in the campaign) serves to brand the Giftpoint name and logo, as well as the little "nametag" icon.

>> The design of this banner—"opening" like a real gift certificate envelope—proves that you can breathe new life into an older, more established form of banner, the GIF.

>> This button reminds visitors of the sophisticated, name-brand retailers featured on Giftpoint.com and appears on an e-greetings site to provide a convenient shopping solution for someone who hasn't yet sent a card and/or gift to friends and loved ones.

>> Again, another large "button" that brands the logo and nametag, featuring some of the high-end, national retailers available on Giftpoint.

Graphic Designer. Jeremy Dybash / **Graphic Designer.** Kellie Fradette / **Graphic Designer.** Brad Lutz / **Graphic Designer.** Shirley McGrath
Tools Used. Adobe Photoshop / Ulead Gif Animator / Allaire HomeSite.

01 02 03 04 05 06 07 08 09 10 11 14

Marketing Objective:

Drive traffic to the Giftpoint.com site and generate purchases of gift certificates.

Creative Strategy:

Increase awareness of the Giftpoint.com brand and site and demonstrate that Giftpoint.com features a large selection of local and nationwide retailers.

Media Placement:

Search engines, e-commerce sites, greeting card services and communities, as well as targeting to human resources employees.

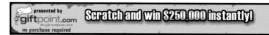

>> Stresses the point that gift certificates from Giftpoint are a convenient, thoughtful gift solution for anybody on any occasion.

>> The Scratch It Rich e-lottery ticket promotion is echoed in the design of this banner, which scratches itself off to reveal the "prize" of a free gift certificate just for participating.

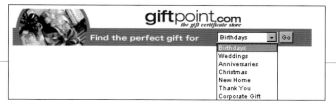

>> You can select the occasion for which you wanted to purchase the gift certificate, thereby increasing interactivity and customizing the user's experience.

>> Borders.com

>> This banner, which announces the "Fall Premiere" of Borders.com's site, is designed to recall the look and feel of glamorous film premieres.

>> Another successful banner in the "Fall Premiere" campaign that uses the Borders.com colors and offers direct search capabilities.

>> The simple message of this HTML banner, "Search For Books," can be executed by putting in any search word to get to a results page on the Borders.com site.

Graphic Designer.Jeremy Dybash / **Graphic Designer**.Kellie Fradette / **Graphic Designer.**Brad Lutz / **Graphic Designer.**Shirley McGrath / **Copywriter.**Meredith Sharp
Tools Used.Adobe Photoshop / Ulead Gif Animator / Allaire HomeSite

01 **02** 03 04 05 06 07 08 09 10 11 12 13 14

Marketing Objective:

Increase awareness of Borders' online presence while emphasizing the look and services of its familiar brick-and-mortar stores: great selection, terrific customer service, live author chats, and special events.

Creative Strategy:

Most of these banners echo the colors of the Borders.com site, which features a large selection of books, as well as music and video, to strengthen brand recognition of both logo and site.

Media Placement:

Run of Site and keywords on Infoseek; CNET.

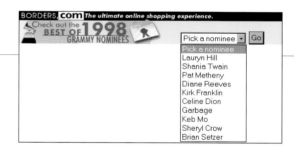

>> Emphasizing the large selection of topics covered at Borders.com, and the fact that purchases are delivered right to your door.

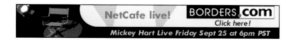

>> An example of a series of "director's chair" banners used to announce live chats with special guests.

>> Borders.com has a special GRAMMY Spotlight to tie in with the music awards; this banner invites the user to select their favorite nominee and go to the site to purchase the nominated music.

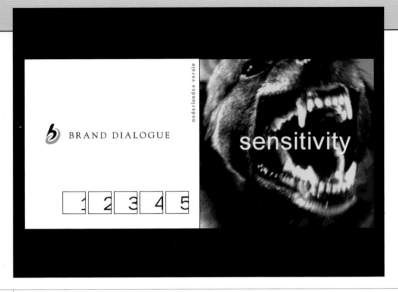
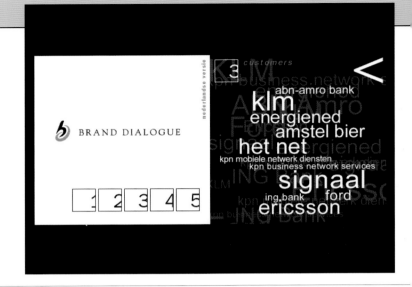

>> Side by side on the Brand Dialogue home page: simplicity and contradiction.

Tying Brands with Consumers

> *One message at a time.*

> *Take what they know, work with it, and make a point.*

> *Never forget you're just a side show to the actual page content.*

>> Building strong relationships based on individual needs.

>> Emotional future promises.

03
Brand Dialogue

Brand Dialogue evolved out of three distinct specialities of Wunderman Cato Johnson Amsterdam—relationship, action, and database marketing—to embrace the possibilities of Web-enabled solutions. During the past four years, growth has come in all areas of the digital arena—from local Web advertising campaigns to international customer retention management (CRM) solutions.

Brand Dialogue believes in the power of the brand as well as the power of the consumer. It uses the Internet not as a mere sales tool, but to enhance the brand experience and take its clients into deep dialogue with their customers. "Our job is making sure that the right dialogue between them happens in the right way in the right place at the right time," says creative director Thor Kunkel.

Kunkel admits, however, that it's tough to live up to the "stickiness" that some of its competitors have achieved with banners that promise to make you "beg for more" (see the pseudo-porn banners below). "Good looks, or whatever you call design, can be an impressive asset of a site, but it's not what makes people click—and stick—to a site," Kunkel says. Creating attraction is what the Web is all about. Good sites attract visitors on a regular basis; a one-time-visitor is a failure.

The first step to stickiness, Kunkel says, is to enable the brand and consumer to get familiar with each other. "People come back for more when they feel your site reflects their personal needs on the spot and offers an immediate response." It's the difference between stylish window dressing and real substance, he says, the difference between boring visitors to death and touching them with a compelling message that builds trust.

"Brilliant, innovative design will always play a major role in our communication, but not more than that," according to Kunkel. "Design is instrumental, not what your site stands for. We aim for the heart of the customer, not his eye. We build brands, and not design frames. We don't present a brand, we make the brand come alive."

And if Brand Dialogue's advertising isn't quite as popular as the pseudo-porn banners it uses to so graphically illustrate its points, it comes as close as is possible this side of prurience.

>> Working on attitude, knowledge and behavior.

>> Explicit interactive instructions.

DISCLAIMER >> WCJ Brand Dialogue does not create porn banners.

Affiliated with Wunderman Cato Johnson Worldwide/Y&R Worldwide / **Address.**Frans van Mierisstraat, 1071 RZ Amsterdam /
Voice.+ 31 20 570 64 84 / **Fax.**+31 20 675 78 70 / **E-mail.**info@brand-dialogue.com / **Web Site.**www.brand-dialogue.com /
Executives.Cas Saeys.Chief Executive, Amsterdam, Thor Kunkel.Creative Director, Amsterdam:

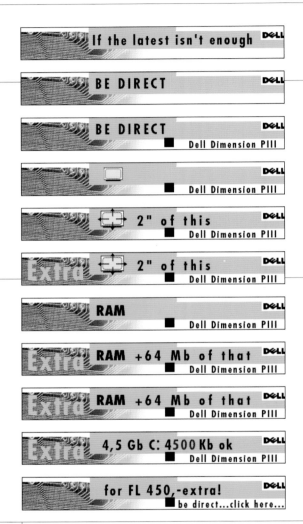

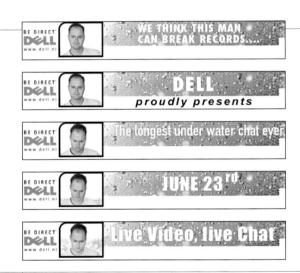

>> The longest underwater chat ever is Dell's first attempt to break six world records in a row, all of which feature Dell computers in extreme environments.

>> "Be Direct" means gaining direct access to the latest products and the latest prices.

Creative Directors, Interactive.Jean Paul Lagendijk and Thor Kunkel / **Art Director.**Yanine Lubbinge / **Copywriter.**Marco Numan / **Interactive Art Director and Programming.**Martijn Hinfelaar / **Studio Interactive.**Ben Hinderink / **HTML.**Margriet Van Vuuren / **Account Director.**Erik Zwiers / **Tools Used.**Adobe Photoshop / Gifbuilder

01 02 **03** 04 05 06 07 08 09 10 11 12 13 14

Marketing Objective:

Create awareness for Dell's E-Direct desktop catalogue, which gives the Internet audience and Dell buyers the latest news about Dell and its special offers.

Creative Strategy:

The banners direct home and small business computer users to a special information page where they may download the E-Direct desktop catalogue application that provides the ultimate convenience when shopping and buying computers.

Media Placement:

Dutch portals like Lycos and Planet Internet, and Dutch computer-related sites.

>> The intro page to the E-Direct desktop catalogue.

>> The catalogue is designed to give people as much access to Dell sales information directly from the customer's computer as possible.

>>

>> Brand Internet's home page relies on simple, familiar icons and shapes.

>> Scroll down the page to see work for its clients.

Good Looking Brands Get Attention

> *No one uses the Internet to view banner advertising.*

> *Don't just go for clicks. Make an impact on the viewers.*

> *Create simple and interesting messages.*

>>"Buy the furniture for your office from your office" launches an e-commerce site that Brand Internet and Netch Technology built for IKEA.

>> Part of a campaign for weekend travel to Iceland through Ticket, the largest travel agency in Sweden; the words are in Swedish playfully written to sound Icelandic.

01 02 03 **04** 05 06 07 08 09 10 11 12 13 14

Brand Internet/Satama Interactive

Brand Internet/Satama Interactive, which was founded in 1998, specializes in the concept, design, and content of Internet solutions for some of the leading advertisers in Sweden including IKEA, NK (the leading department store), Posten (the postal service), Ericsson, and startups like Matomera (an online grocery store). Its focus, says chief executive and creative director Ajje Ljungberg, is always on the brand. The way the brand looks is critical to its success. "Quite simply, good-looking brands get more attention," says Ljungberg. "We are convinced that great design and copy is as important as efficient technological performance when you are building functional Internet solutions."

In effect, Brand Internet is an information architect for the Internet. "Though we don't build our solutions as metaphors from the real world, we still see the process as similar to developing real estate like, for example, shopping malls or office centers," says Ljungberg. "It's about solving parking problems, making nice entrances, ensuring that restrooms and other convenient services are there to make life easier for customers and tenants. In the virtual world, that means enough bandwidth, functional design, efficient search resources, and intuitive navigation."

Brand Internet has won several awards for its creative work, including Scandinavian Interactive Media Event (SIME) awards, and a diploma from Guldägget (The Advertising Award of Sweden) for a campaign for NK. "Our greatest resource is that we're gathering the best Web designers in Scandanavia," says Ljungberg.

Swedish marketers are now focusing more of their marketing budgets on online advertising. Revenue, which was 207 million Swedish crowns (SEK) in 1998, is expected to reach 500 million SEK, or about $58 million U.S., in 2000. They are targeting what is perhaps the savviest online audience in the world. Swedes enjoy an excellent telecom infrastructure, high education, and good skills in English. Nearly half of the 3.3 million people between the ages 15–79 use the Internet frequently, and 68% of those between 15–44 use it every month.

The most common online advertising in Sweden is the ordinary banner. Recent inroads have been made by ads that cover the whole screen for 10 seconds before the user can go on (interstitials), and less-intrusive pop-ups. Campaign sites, such as the ones on the following pages for Svenska Naturskyddsföreningen and Ericsson's ERICA Awards, are also popular. "Cutting-edge technology and crispy, good-looking design work hand in hand to establish great Web sites and advertising," Ljungberg concludes. "We definitely believe that if it looks good, it works better."

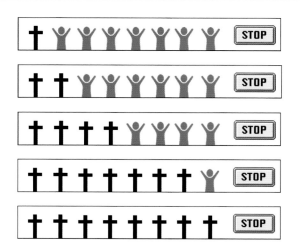

>> This entry for a banner-advertising competition for Rädda Barnen, the Swedish "Save the Children" organization, was deemed too controversial to participate.

>> Rädda Barnen approved this gentler approach but it did not generate the click-rates Brand Internet believes the banner with the crosses would have received.

Address.Birger Jarlsgatan 18D, 114 85 Stockholm Sweden / **Voice.**+46-8-506 124 10 / **Fax.**+46-8-506 124 39 / **E-mail.**info@brandinternet.com /
Web Site.www.brandinternet.com / **Executives.**Ajje Ljungberg.Chief Executive and Creative Director

>>

>> No words, no cutting-edge technology, just an intriguing graphic.

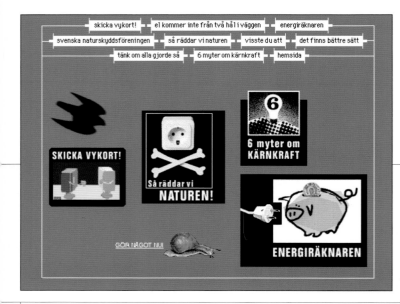

>> Visitors can choose between different pages, read about the myths of nuclear power, calculate the amount of energy used by various appliances, send postcards, and more.

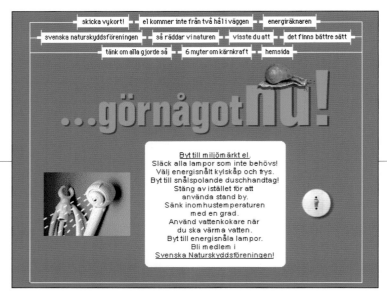

>> The copy tells people they can make a difference in their own households by saving energy.

01　02　03　**04**　05　06　07　08　09　10　11　12　13　14

Marketing Objective:
Drive people aged 15 –18 to a campaign site for Svenska Naturskyddsföreningen, a Swedish environmental organization, where they learn how to use less energy in their households.

Creative Strategy:
The campaign site is designed to be playful and fun, to attract young people; the sole banner consists simply of a piece of wallpaper with a light switch.

Media Placement:
The Swedish AltaVista site.

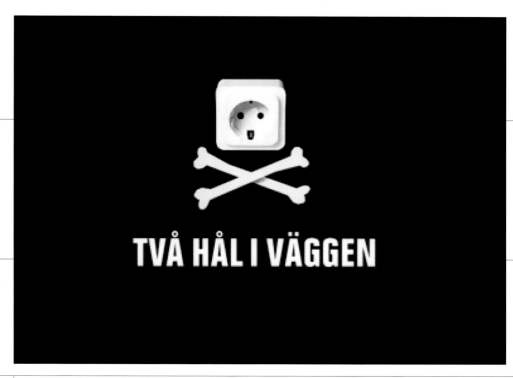

>> The skull symbol succinctly parodies the very successful "Two Holes in the Wall" ad campaign for a large Swedish energy company.

Creative Director.Ajje Ljungberg / **Art Director.**Tone Knibestöl / **Account Manager.**Jenny Rosén / **Web Designer.**Björn Ståått
Tools Used.Adobe Photoshop / HTML / Imageready

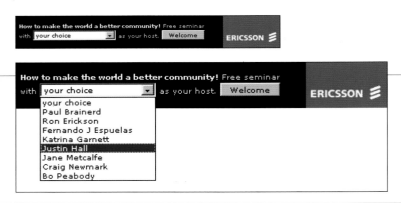

>> Many prominent names are featured in the drop-down list of
Internet visionaries who conduct online seminars for ERICA.

>> The ERICA symbol.

>> The site features brief summaries of the accepted entries, as well as URLs to the existing Web
sites. Site visitors can view the entries alphabetically, by category (e.g., Art & Culture), or use the
search engine.

01 02 03 **04** 05 06 07 08 09 10 11 12 13 14

Marketing Objective:

Create a concept and Web Site for Ericsson that supports its efforts to strengthen its position within the Internet community and shows it understands the "soul of the Net."

Creative Strategy:

The international ERICA competition encourages nonprofit agencies to compete for prize money to build Internet solutions working with Ericsson CyberLab and nine Web developers from three continents. The Web site provides information about the entries as well as online seminars with prominent guests.

Media Placement:

Banners on pj.org, fastcompany.com, wired.com, news.com, tecweb.com/wire, and internetwk.com; public relations campaign through Edelman Public Relations Worldwide to spread the world about ERICA.

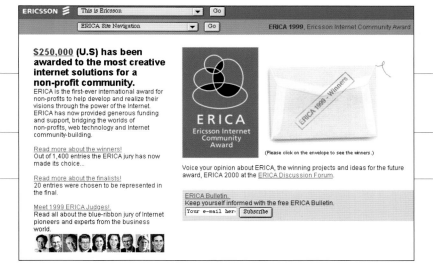

>> Complete entry information is available for the Top 20 concepts picked by a prominent panel of judges.

>> Of the more than 1,400 organizations competing, three are chosen—but the information and resources on the site continue to inform nonprofits and enhance the Ericsson brand.

Creative Director.Ajje Ljungberg / **Account Manager.**Pija Sundin / **Art Director.**Fredrik Lewabder / **Web Designer.**Johan Eklund / **Copywriter.**Christina Knight /
Database Programming.Bazooka Interactive / **Tools Used.**Adobe Photoshop / HTML / Microsoft Access database / ASP technology

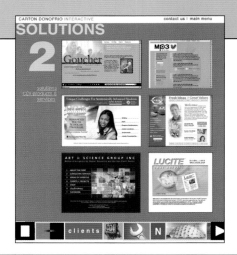

>> Digital brand-building by Carton Donofrio Interactive.

>> Carton Donofrio Interactive's homepage with scrolling Flash navigation.

Know the User

> *Commercial speech can no longer be one-way communication.*

> *Interactive media can change the world for the better.*

> *People aren't idiots.*

>> Art & Science Group's reputation is grounded on facts; these rotating factoids created —in Shockwave—build the brand while generating interest.

>> These Shockwave "Power Games" for Baltimore Gas and Electric reach kids with important safety information while they are having fun.

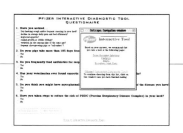

>> The Interactive Diagnostic Tool for Pfizer helps farmers diagnose problems with their animals.

>> The banner launches the image of Arclig's logo, which comes in from the right like a bullet.

01 02 03 04 **05** 06 07 08 09 10 11 12 13 14

Carton Donofrio Interactive

CDI, founded in 1994 as RMD Interactive, was spun off as a separate company headed by Sean Carton and Chuck Donofrio in 1995. Since its founding, CDI has provided comprehensive digital-marketing communication services to companies such as Pfizer, Rubbermaid, Armstrong, Sylvan Learning Systems, Giant, AnnuityNet, Baldwin, and Open University. CDI also offers a wide range of offline electronic communications products including CD-ROM catalogs, kiosks, OneCall Sales Support Systems, motion graphics, and presentations.

"At CDI, we have one overriding principle," says Sean Carton, managing partner of Carton Donofrio Interactive. "Everything we do—everything—must flow from user insight."

Understanding the user is an integral part of the design and development process at CDI.

"You can't design in a vacuum," points out art director Peter Quinn. "You have to know who you're communicating with, what they need, and how the client's product or service fits that need. Forget all the technology—the brain is the most important design tool around."

CDI's interactive media development process begins during an account planning phase when research, user insight, and information are gathered. After getting a clear understanding of the communications challenge, CDI then synthesizes what it has learned into a plan that will guide the rest of the project.

Next, the designers take that plan and begin to shape it into a top-level prototype. "This is a critical phase," points out Carton. "It's where we build the foundation, the groundwork for the rest of the program. It's an interactive process—testing is important here. We prototype, test, refine, and test again until we've got something that's going to do the job."

After the top-level prototype is set, the design staff works with the programming staff to integrate functionality and design. "The Web isn't print and it isn't TV," underlines Andres Zapata, senior multimedia developer. "It's a whole new medium with a whole new set of challenges. What we do has to communicate. It has to make peoples' lives better. It has to recognize that we're dealing with a two-way medium. Our code must work seamlessly with the design to be greater than the sum of its parts."

Kirby Kaufman, director of business development, underscores the importance of appropriate design. "There's a great misconception that print designers can intuitively design for the Web. It's much like asking them to assemble and then operate a six-color printing press. In the dark."

Once the initial design and coding is in place, CDI then moves into the assembly and testing phase. The project is put together, the ad created, the back-end programmed, and the entire package re-tested again by users. If it works, it's submitted to the client for final approval. If it doesn't, it's refined again.

At CDI, a project doesn't end the day it goes live. The agency believes that measuring the success of the project is vital. "The Web has destroyed the lines between what's advertising and what's not, and simple measures that might have worked for the traditional ad world don't always apply," says Carton. "In some cases, raw traffic to a site might be the goal. In another, driving inquiries to franchisees might be what we're trying to accomplish. Other clients want to measure by the number of new customers. You have to know what you're trying to accomplish before you can know if you're successful. And our clients' success is our bottom line."

ARCLIG INDUSTRIES

15 16 17 18 19 20 21 22 23

A wholly-owned subsidiary of Richardson, Myers & Donofrio **Address.**120 West Fayette Street, Baltimore MD 21201 /
Voice.410 576 9000 / **Fax.**410 752 2191 / **E-mail.**sean@cdinteractive.com / **Web Site.**www.cdinteractive.com /
Executives.Sean Carton and Chuck Donofrio.Managing Partners, Peter Quinn.Art Director

>>

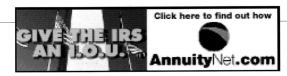

>> This button ran in a popular financial-management software package.

>> These banners ran on lifestyle as well as business and financial sites.

>> This banner ran on financial Web sites during tax time.

Creative Director.Ken Majka / **Art Director.**Margie Weeks / **Senior Multimedia Designer.**Andres Zapata
Tools Used.Adobe Photoshop / Adobe Illustrator / Macromedia Fireworks

01　02　03　04　**05**　06　07　08　09　10　11　12　13　14

Marketing Objective:
To drive traffic to the AnnuityNet.com Web site in order to sell variable annuities.

Creative Strategy:
Develop a series of highly provocative banners to attract consumers who face the danger of outliving their retirement savings. Emphasizes the consequences of good or bad financial planning by reminding consumers that they control their own financial destinies.

Media Placement:
Since AnnuityNet.com is a somewhat novel product on the Web, Carton Donofrio conducted a two-month test in three categories: business/financial sites (transaction sites versus vertical content), lifestyle/enthusiast (sports, travel, health), and portal sites (financial content and keywords).

www.**AnnuityNet.com**

An old school investment radically updated.

Click here to find out how **AnnuityNet.com**

>>

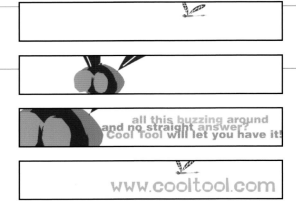

>> "Buzzing," another rich-media mini-movie, uses the movement of a small fly to draw interest and hold it as the pesky bug flies straight at the screen and meets its demise in a virtual splat.

>> Displaying the words entered by an off-screen user into the "search" window, this 38K mini-movie in Flash gives users a complete sense of the Cool Tool brand while simultaneously showing what words are commonly used to find the site.

 >>

>> Announcing Cool Tool Network's range of daily entertainment options while engaging the eye with a hypno-spiral.

Managing Partner.Sean Carton / **Senior Multimedia Developer.**Andres Zapata / **Art Director.**Peter Quinn
Tools used.Adobe Photoshop / ColdFusion / Adobe Illustrator / Macromedia Fireworks / Flash 2

01 02 03 04 **05** 06 07 08 09 10 11 12 13 14

Marketing Objective:

To drive new traffic to www.cooltool.com and increase audience reach by expanding the audience to include managers and decision makers.

Creative Strategy:

Targeted, bold designs that emphasize the offerings of the Cool Tool Web site, as well as its associated sites on the Cool Tool network. The quirkiness—some call it charm—of the site is emphasized.

Media Placement:

On various marketing, advertising, and technology sites.

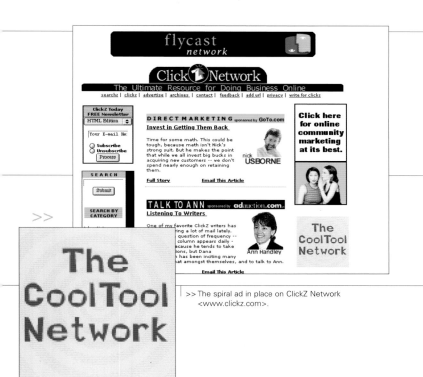

>> The spiral ad in place on ClickZ Network <www.clickz.com>.

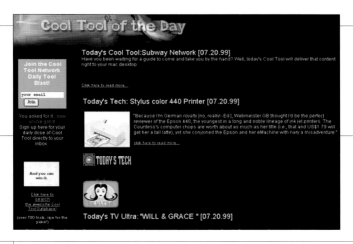

>> Software tools, hardware reviews, and TV shows await visitors to the homepage of the Cool Tool Network at <www.cooltool.com>.

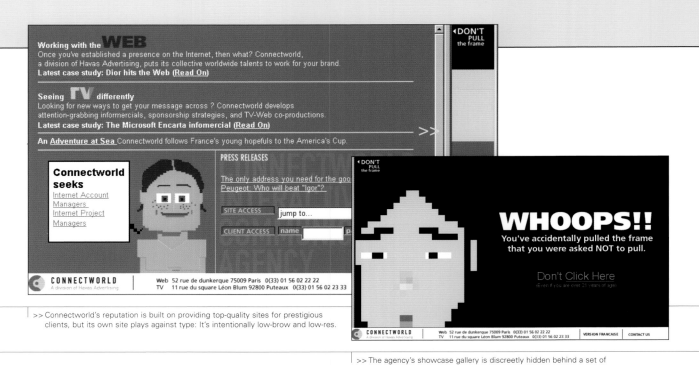

>> Connectworld's reputation is built on providing top-quality sites for prestigious clients, but its own site plays against type: It's intentionally low-brow and low-res.

>> The agency's showcase gallery is discreetly hidden behind a set of contradictory instructions ("Don't Click Here").

Dishing Up
Three-Course Web Sites

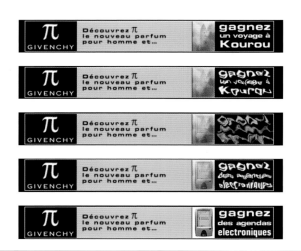

>> For the European launch of π, Givenchy's new men's fragrance, Connectworld organizes an online game and contest.

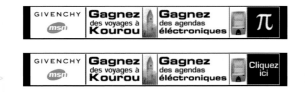

>> The game allows players to "journey into outer space" and bring back clues that will lead them to participate in a prize drawing.

06
Connectworld

Connectworld was created in 1997 to consolidate the strengths and resources of the Havas Advertising group in the field of multimedia. Today more than 150 people work at the heart of Connectworld to define interactive strategies for a list of clients that includes, on a world-wide basis, Intel, Microsoft, Peugeot-Citroen, and Philips, and regionally, Dior, Hennessy, and Iomega.

At Connectworld's Paris headquarters, designers, programmers, and client representatives work in close proximity, mixing and matching their respective talents. "We first tried organizing the office by areas of expertise, giving Connectworld the kind of structure you might find in a traditional advertising agency—account management over here, creative over there; bosses in one place, staff in another," notes CEO Pierre Louette. "But working almost exclusively on the Web has led us to break with tradition. What's required is less hierarchy and more team spirit."

These organizational changes have resulted in clear divisions by task and by project—and some fuzziness when it comes to business-card titles. "'Designer' has become a non-specific job description here," admits design director Laurent Thomas-Gérard. "Graphic artists, Flash specialists, illustrators, composers, copywriters, we're all in it together. It's a good thing we all get along."

Thomas-Gérard supervises Connectworld's design activities, sharing responsibilities with Randall Koral, Connectworld's editorial director. One works with images, the other with words, but they don't seem to mind stepping on each other's toes. "We're like The Thing With Two Heads," says Thomas-Gérard. "We have different backgrounds and different approaches, but we agree on the important things." Koral spends his time "making words do what they're supposed to do." He says, "It's not like in a newspaper, where words are only something you read. On the Web, you might read a word, click on it, listen to it, or talk back to it."

> *Graphic design isn't just the dessert; it's what makes you hungry in the first place.*

> *Good Web content should provide all your nutritional requirements and make you eager for a second helping.*

> *A Web site without a business model is like a dinner without food.*

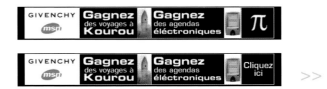

>>

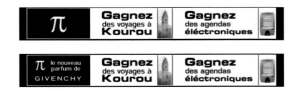

>> The grand-prize winner in the contest gets to watch a rocket launch in Kourou.

A Division of Havas Advertising / **Address.**52 Rue de Dunkerque, 75009 Paris France / **Voice.**+33 1 5602 2222 / **Fax.**+33 1 5602 2223 / **E-mail.**contact@connectworld.fr / **Web Site.**www.connectworld.fr / **Executives.**Pierre Louette.CEO, Laurent Thomas-Gérard.Design Director, Randall Koral.Editorial Director

Parfums Christian Dior

>> This banner for Diorific Plastic Shine lip gloss offers to transform lips as well as the personality of their owner.

>> This banner, which achieved one of the highest click-through rates for a Dior product, became a collector's item.

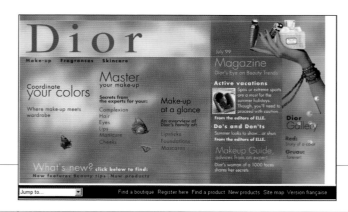

>> The homepage for Parfums Christian Dior, animated with butterflies and an original music score, features a "magazine" section in addition to a complete catalogue of the company's products.

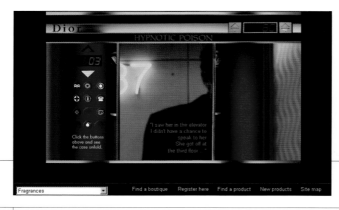

>> The launch of Hypnotic Poison perfume encouraged Connectworld to create an intriguing mini-site, a Web-noir mystery involving a vanished femme fatale.

General Director.Jérôme Wallut / **Client Manager.**Elise Viguier / **Marketing.**Aurélien Seydoux / **Design Director.**Laurent Thomas-Gérard / **Editorial Director.**Randall Koral / **Technical Director.**Fréderic Dufils / **Art Director.**Guillaume Joire / **Web Designers.**Sébastien Barthélémy, Elsa Charavit / **Programmers.**Dessimira Manolova, Paul Demare / **Network and Systems Engineer.**Charles Rouillon / **Project Director.**Aurélia Ammour / **Project Managers.**Lorraine Le Tac, Cédric Soyez, Christelle Merlet

01 02 03 04 05 **06** 07 08 09 10 11 14

Marketing Objective:

Parfums Christian Dior was looking to arrive on the Web in a big way, with a site that would feature the company's vast range of perfume, make-up, and skincare products.

Creative Strategy:

Connectworld's site for Dior, unveiled at the end of 1998, is a study in contrasts, a site that reaffirms the company's traditional image while at the same time emphasizing a talent for innovation. Mini-sites accompany the launch of each significant Dior perfume, make-up, or skincare product.

Media Placement:

Banners are periodically placed on the beauty pages of search engines as well as on Web sites of proven interest to women. Connectworld has also developed special advertising and referencing campaigns to coincide with launches of specific Dior products.

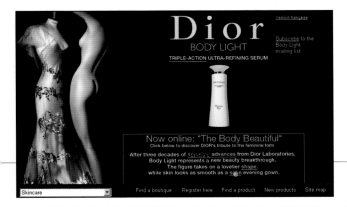
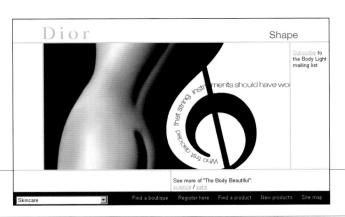

>> Dior's site features an exhibit dedicated to "The Body Beautiful" divided along three lines: Shape, Satin and Science.

Tools Used. Adobe Photoshop / Macromedia Flash / Macromedia Director / JavaScript

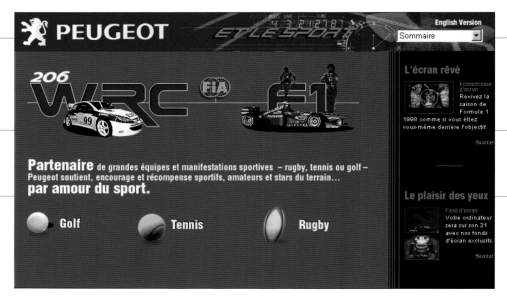

>> Peugeot wanted a section that would spotlight the company's involvement in Formula 1 and World Rally and also highlight Peugeot's long-time sponsorship of tennis, rugby, golf, and other activities.

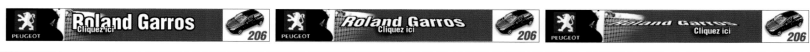

>> During the French Open at the Roland Garros stadium, Peugeot's site unveiled the 206 Roland Garros model, and featured a virtual tennis game ("Beat Igor and Win Prizes").

01 02 03 04 05 **06** 07 08 09 10 11 12

Marketing Objective:

Peugeot was an Internet pioneer, launching its Web site in 1995. Three years later, this site contained more than 6,000 pages (in three languages) and was in desperate need of a rethink.

Creative Strategy:

Connectworld developed a strategy to reposition Peugeot's site along two main lines. First, Peugeot.com exists principally to attract and inform, demonstrating how Peugeot's cars are "engineered to be enjoyed." Next, this "hub" site automatically dispatches prospective buyers to local sites maintained and updated by Peugeot's affiliates around the world.

Media Placement:

In addition to creating and placing banners each time Peugeot launches a new model, Connectworld has developed targeted advertising campaigns to coincide with annual events such as the French Tennis Open (of which Peugeot is a sponsor) or the Paris World Motor Show.

General Director.Jérôme Wallut / **Client Manager.**Laurent Demas / **Marketing.**Aurélien Seydoux / **Design Director.**Laurent Thomas-Gérard / **Editorial Director.**Randall Koral / **Technical Director.**Fréderic Dufils / **Art Directors.**Thomas Aubrun, Guillaume Joire / **Web Designer.**Sébastien Barthélémy / **Web Designer,Programmers.**Dessimira Manolova, Paul Demare / **Network and Systems Engineer.**Charles Rouillon / **Project Director.**Aurélia Ammour / **Project Managers.**Delphine Bertrand, Laurence Duby, Pascal Malotti

>> This banner announces Peugeot's special offer for tourists visiting Paris.

>> This banner, one of Peugeot's most successful for click-throughs, offered a glimpse at a car everyone has been waiting to see—the 206 S16—during the Geneva World Motor Show.

01 02 03 04 05 **06** 07 08 09 10 11 12 13 14

>> Connectworld introduced a section on the Peugeot site devoted to concept cars, an important, if little understood, area of activity.

Tools Used. Adobe Photoshop / Macromedia Flash / Macromedia Director / JavaScript

It's All in the Idea

> *Stay true to the brand, stay true to the medium.*

> *Technology should enhance a brand, not obscure it.*

> *Never lose sight of the customer.*

Darwin Digital

Darwin Digital employs powerfully striking designs to make smart ideas spring to life on the Internet. In a medium driven by technology, Darwin Digital remains focused on individuals, using design to engage consumers on a personal level. "We view each new technology as a design opportunity," says chief executive Coby O'Brien, "a way of devising innovative advertising executions to enhance the power of established brands on the World Wide Web."

Darwin, a hybrid between an interactive agency and a production house, looks at its clients' businesses from technical, creative, and marketing viewpoints. Founded in New York as Saatchi & Saatchi Interactive in 1994, the agency became Darwin Digital in 1997 and opened offices in San Francisco and New Zealand. Evangelists for the power of strategy and innovation, Darwin's own trademarked tagline is "Permanent Brainstorm," followed by "providing clients with a constant stream of ideas, information, and opportunities."

On the Internet, there is an opportunity to go beyond presenting a brand to letting the user experience it. This often means creating greater accessibility to information and adding functionality to the ad unit. Darwin has had great success with online advertising that allows consumers to:

- Go directly to an article of interest;
- Complete a form or obtain information without leaving the banner;
- Experience the brand message by playing a game or participating in a product demonstration.

Unlike any other medium, the Web requires constant interaction with the user. Darwin uses this to its advantage and involves users as much as possible. "The more they interact with the advertising," says O'Brien, "the more they will learn about the brand or product."

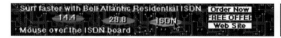

>> Banners for Bell Atlantic ISDN were designed with Java applets, allowing users to get information or sign up without leaving the host page.

>> Darwin's proprietary iFly technology allows third-party, real-time content changes, enabling Mercury Center to update banner ads as news breaks.

A Saatchi & Saatchi Vision Company / **Address.**375 Hudson Street, New York NY 10014 / **Voice.**212 807 3700 / **Fax.**212 807 3725 / **E-mail.**contact@darwindigital.com / **Web Site.**www.darwindigital.com / **Executives.**Coby O'Brien.Chief Executive Officer

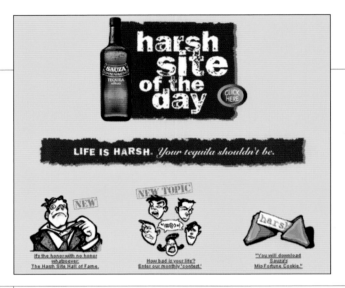

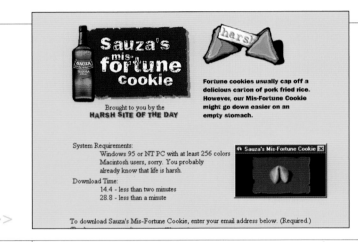

>> Harsh.com Homepage: Darwin uses creative banner and button advertising, keywords on search engines, and co-marketing efforts to drive users to the Sauza Web site. The online version of the campaign complements its offline counterpart, using a distinctly edgy and youth-oriented visual approach to appeal to a primarily Generation X audience. Prominent product placement and branding, coupled with catchy illustrations, make for an engaging and memorable design.

>> The downloadable "Virtual Fortune Cookie" application carries the Sauza brand off the Internet and on to users' personal computers. It randomly generates "Mis-Fortunes"—humorous fortunes adhering to the "Life is Harsh" theme of the offline campaign. More than 12,000 people have downloaded this application, and many more have received it through friends' e-mail.

 >> >>

>> Banners containing the Mis-Fortune cookie are part of the marketing promotion campaign to drive users to the site. In addition, the URL appears on all advertising and some packaging, search listings are kept up-to-date, and an aggressive public relations campaign generates coverage in print and online.

01 02 03 04 05 06 **07** 08 09 10 11 12 13 14

Marketing Objective:

Expand and build upon Sauza Tequila's "Life is Harsh" campaign, taking advantage of the Web's capacity for "viral marketing" to create buzz around the Sauza brand.

Creative Strategy:

Visitors to www.harsh.com expand their relationship with the Sauza brand. The site offers a daily link to eclectic third-party Internet content that embodies the "Life is Harsh" theme of the offline campaign. This encourages high-repeat traffic and maintains awareness of the brand through entertainment. In addition, visitors are encouraged to suggest content, thereby creating a participatory community and fostering brand loyalty.

Media Placement:

Popular culture and youth-oriented Web content properties.

 >> >> >>

Account.Jenny Burns, Shana Hunter / **Media.**Anthony Mazarella / **Creative.**George Decker, Morgan Carroll / **Producer.**Stacy Perchem / **Technology.**Daniel Reznick
Tools Used.Adobe Photoshop / Adobe Illustrator / Allaire Homesite

>> Macromedia's Director 7 Shockwave Internet Studio

>> "Burst" demonstrates that using Director 7 Studio to create Shockwave content delivers rich, quality graphics and animation to enhance Web designs and make them more immersive.

>> The "Counter" execution, targeting marketing executives and Internet business strategists, highlights the benefit of Shockwave content from a business perspective—immersive online experiences translate into increased traffic.

Account Directors. Yvonne Lim, Teresa Julian / **Creative Director.** Ali Ebtekar / **Producer.** Debra Tyler / **Technology.** Ali Ebtekar, Alex Currier
Tools Used. Macromedia Director with Enliven Xtra / Adobe Photoshop / 3D Studio MAX / DeBabelizer Pro / SoundEdit 16

01 02 03 04 05 06 **07** 08 09 10 11 12 13 14

Marketing Objective:

Support the launch of Macromedia's Director 7 Shockwave Internet Studio and drive traffic to the Director 7 Studio information and purchase page, or get users to print a fact sheet about the product.

Creative Strategy:

Targeting Web designers and marketing executives, Darwin wants to demonstrate that Director 7 Shockwave Internet Studio lets users create a whole new class of immersive, rich media content for the Internet. Rather than tell users about the product, these executions show them.

Media Placement:

Web developer, technology, and Internet business strategist sites, as well as complementary sponsorships.

 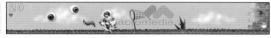

>> The "I-balls" rich media banner was created to coincide with Macromedia's print effort. The print headline reads, "Shockwave Web sites grab you by the eyeballs." As you play the game, you learn more about the Shockwave Player. When you catch a Shockwave logo, your net expands and you are able to catch more eyeballs (a metaphor for how Shockwave content will attract more viewers to your site).

MercuryCenter

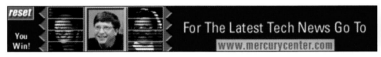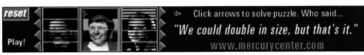

>> Darwin created "Faces," a fun and engaging game-like banner, that challenges tech-savvy readers to piece together the face of the well-known industry professional quoted.

Account Directors.Rebecca Gaspar, Teresa Julian / **Media Director.**Dianne Hayashi / **Creative Directors.**Ali Ebtekar, Diane Gibbs / **Producer.**Debra Tyler / **Technology.**Daniel Reznick, Ali Ebtekar
Tools Used.Ifly / Dreamweaver / Adobe Photoshop / DeBabelizer Pro

01 02 03 04 05 06 **07** 08 09 10 11 12 13 14

Marketing Objective:

Reinforce MercuryCenter's positioning as the definitive source for high-tech news and drive traffic to the site.

Creative Strategy:

The campaign supports MercuryCenter's positioning by providing reliable, up-to-the-minute technology news in banners targeted at active Web users seeking high-tech business news and information. Users click on headlines of interest and are linked directly to that story without needing to search for it on the site.

Media Placement:

Business, financial, and technology focused sites.

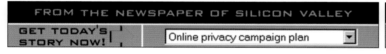

>> This banner, with an HTML pull-down menu, allows users to choose from several top news stories.

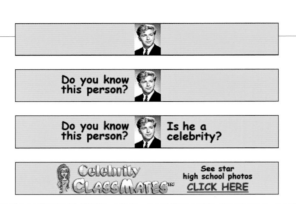

>> Appealing to the public's fascination with celebrities to get people to click through to a site that reunites alumni.

>> A shameless verbal and visual pun on the ubiquitous "click here" in a banner for a vitamin supplement company.

>> eyescream's saucy and irreverant opening pages.

Killer Creative and Design

> *If you're not on the edge, you're taking up too much space.*

> *Hunter S. Thompson meets J. Walter Thompson.*

> *Advertising in overdrive; technology on acid.*

eyescream interactive

Mark Grimes started eyescream interactive in 1996, making it one of the first exclusively interactive agencies. Grimes had established himself as an innovator from the founding of Grimes Communications in 1989, a company noted for its work with prestigious national arts and culture organizations. Today eyescream is a full-service online agency, offering creative services, media planning and buying, online public relations, and other marketing and promotions services.

In the noisy environment of the Internet, eyescream believes the challenge is clear: Define the client's space, and nail it. Then nail it again. Don't get comfortable, because it will all change tomorrow—or this afternoon. "In the world of the Internet, if you're up to date, you're two years behind the front runner," says Grimes, "and, potentially, the competition."

Media placement strategies play a huge role in this challenge, but without creative that grabs the eyeballs and won't let them go, those strategies don't mean much. eyescream's approach is to avoid comfort. It focuses on constant evaluation of creative to determine what gets clicks, a keen awareness of the latest techniques in generating creative, and a commitment to setting trends rather than following them.

"Online advertising exists in a tactile environment which is looking for users to do something," notes Grimes. "Your audience is involved and engaged by the medium; the advertising we create better live up to that and demand, compel, and inspire action. This is both the great opportunity of designing advertising for the Web and the greatest challenge."

eyescream has built its unique niche in the market through audacious creative. But its wide range of clients also demands that it be prepared to adjust to their tastes and attitudes. "We strive to keep our relationships with clients refreshingly candid," says Grimes. "We can feel free to submit the most creative concepts and marketing tactics that we can dream up in our fevered imaginations, while they have the freedom to shoot them down and suggest something different. We just hope that we're able to convince them to follow us down the intrepid road more often than not."

The mix of what produces results on the Web is changing so often, eyescream walks its talk by creating new ways of driving traffic through creative, including the development of proprietary creative marketing tools (see www.zthing.com) and actively pursuing new placements and sizes of creative with publishers. "This medium is too new to settle into any sorts of established patterns. We need to redefine the term 'killer creative' weekly," says Grimes. "It is an exciting frontier to work in, but it is one that is still relatively unmapped. We can't fall back on history to convince a client, or ourselves, that something will work. We rely instead on our own experience and our—we think—reliable instincts."

"'Eyescreamers' frequently repeat the mantra, 'If you're not on the edge, you're taking up too much space," Grimes says. "It reminds us that if you shoot for the moon and are less than successful, at least you're somewhere in space."

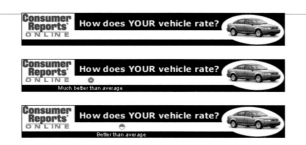

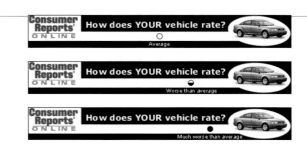

>> Broad media placement for StyleClick.com allows eyescream to experiment with unusual banner sizes and play up the attraction of selection with the pull down menu.

>> Leveraging Consumer Reports' reputation as the place to gather consumer information with the familiar ratings graphics.

Address.17650 NW Gilbert Lane, Portland OR 97229 / **Voice.**503 292 6987 / **Fax.**503 296 0945 / **E-mail.**info@eyescream.com / **Web Site.** www.eyescream.com / **Executives.**Mark Grimes.President and Founder, Mark Watson.Creative Director

>>

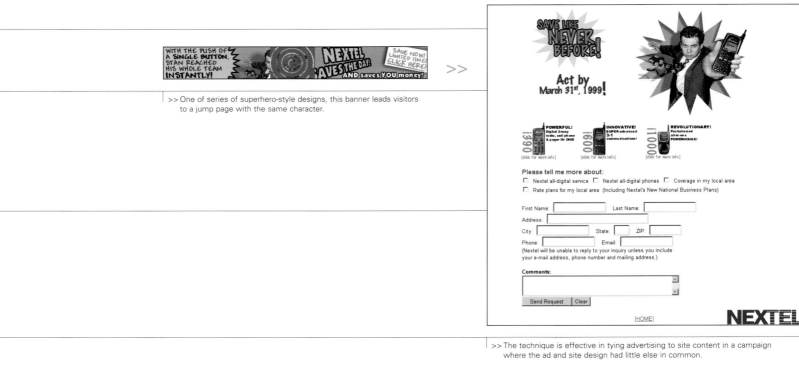

>> One of series of superhero-style designs, this banner leads visitors to a jump page with the same character.

>> The technique is effective in tying advertising to site content in a campaign where the ad and site design had little else in common.

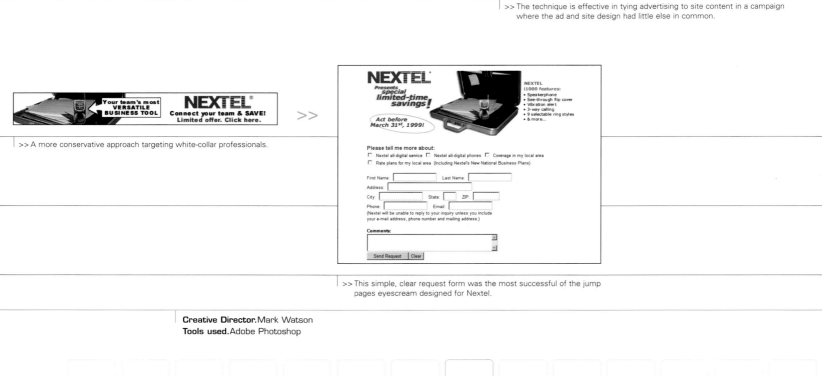

>> A more conservative approach targeting white-collar professionals.

>> This simple, clear request form was the most successful of the jump pages eyescream designed for Nextel.

Creative Director. Mark Watson
Tools used. Adobe Photoshop

01 02 03 04 05 06 07 **08** 09 10 11 12 13 14

Marketing Objective:

Generate leads for a sales promotion featuring discounts on phones and a no-roaming service plan by driving prospects to nextel.com, where they provide contact information.

Creative Strategy:

The campaign alternates between a fun, colorful approach with the superhero-type banners and the more conservative "be prepared" mentality represented by the briefcase and pocket knife.

Media Placement:

Primarily business and business management sites.

>> Stressing preparedness, and targeting gray- and blue-collar audiences, this animated banner leads to another jump page.

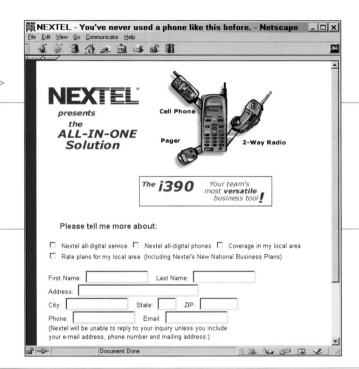

>> The jump page graphic plays off the Swiss Army Knife theme.

>> A simple but not-so-subtle psychological pitch.

>> This ad culminates in an explosion as the cell phone, pager, and two-way radio collide and form the essential Nextel phone with features of all three.

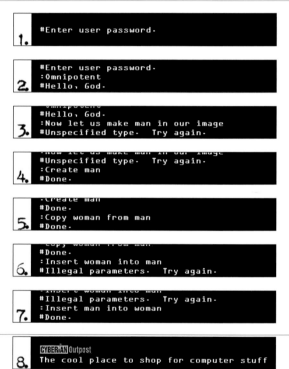

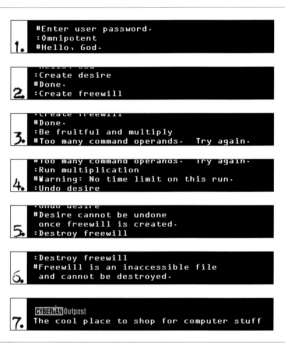

1.
```
#Enter user password.
```

2.
```
#Enter user password.
:Omnipotent
#Hello, God.
```

3.
```
#Hello, God.
:Now let us make man in our image
#Unspecified type.  Try again.
```

4.
```
#Unspecified type.  Try again.
:Create man
#Done.
```

5.
```
:Create man
#Done.
:Copy woman from man
#Done.
```

6.
```
#Done.
:Insert woman into man
#Illegal parameters.  Try again.
```

7.
```
#Illegal parameters.  Try again.
:Insert man into woman
#Done.
```

1.
```
#Enter user password.
:Omnipotent
#Hello, God.
```

2.
```
:Create desire
#Done.
:Create freewill
```

3.
```
:Create freewill
#Done.
:Be fruitful and multiply
#Too many command operands.  Try again.
```

4.
```
#Too many command operands.  Try again.
:Run multiplication
#Warning: No time limit on this run.
:Undo desire
```

5.
```
:Undo desire
#Desire cannot be undone
 once freewill is created.
:Destroy freewill
```

6.
```
:Destroy freewill
#Freewill is an inaccessible file
 and cannot be destroyed.
```

7.
```
CYBERiAN Outpost
The cool place to shop for computer stuff
```

>> A new banner released each day creates a small serial story.

8.
```
CYBERiAN Outpost
The cool place to shop for computer stuff
```

>> Each banner features an interaction between God and a computer,
using classic computer errors as impediments to the creation of earth.

01 02 03 04 05 06 07 08 09 10 11 12 13 14

Marketing Objective:
Distinguish Cyberian Outpost as the place online to buy computer software and hardware in early 1997, when many computer-supply companies were vying for share of mind.

Creative Strategy:
Combining direct response with a strong branding approach, eyescream incorporates a popular mass e-mail that spoofs the notion of the creation of the universe into a series of five banners, capitalizing on the already created buzz.

Media Placement:
Fresh banners every day on sites where daily content changes keep loyal users visiting frequently.

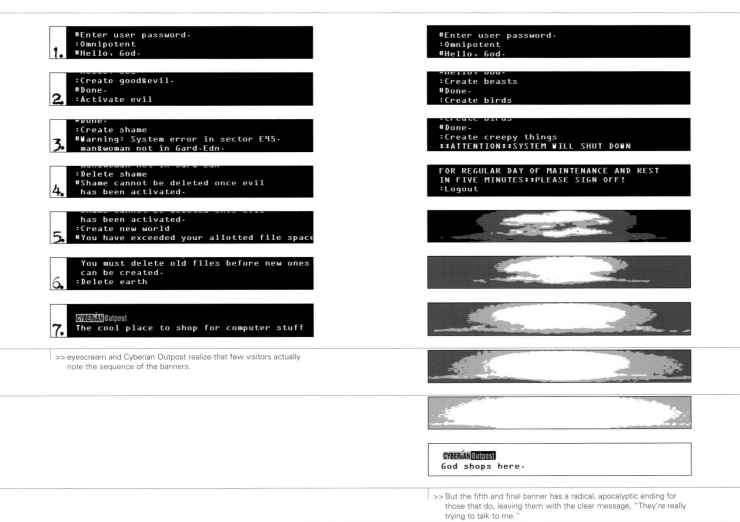

1.
```
#Enter user password.
:Omnipotent
#Hello, God.
```

2.
```
:Create good&evil.
#Done.
:Activate evil
```

3.
```
:Create shame
#Warning: System error in sector E95.
 man&woman not in Gard-Edn.
```

4.
```
:Delete shame
#Shame cannot be deleted once evil
 has been activated.
```

5.
```
has been activated.
:Create new world
#You have exceeded your allotted file space
```

6.
```
You must delete old files before new ones
can be created.
:Delete earth
```

7.
```
CYBERIAN Outpost
The cool place to shop for computer stuff
```

>> eyescream and Cyberian Outpost realize that few visitors actually note the sequence of the banners.

```
#Enter user password.
:Omnipotent
#Hello, God.
```

```
#Hello, God.
:Create beasts
#Done.
:Create birds
```

```
#Done.
:Create creepy things
**ATTENTION**SYSTEM WILL SHUT DOWN
```

```
FOR REGULAR DAY OF MAINTENANCE AND REST
IN FIVE MINUTES**PLEASE SIGN OFF!
:Logout
```

```
CYBERIAN Outpost
God shops here.
```

>> But the fifth and final banner has a radical, apocalyptic ending for those that do, leaving them with the clear message, "They're really trying to talk to me."

President. Mark Grimes / **Creative Director.** Mark Watson
Tools used. Adobe Photoshop

>> Freestyle Interactive's homepage and pull-down menu of clients.

Building Next-Generation Communications

> *Look striking, perform seamlessly, and produce results.*

> *Rich media is the future of advertising.*

> *The GIF banner is dead.*

>> Freestyle and Bozell Worldwide convey the thrill of the chase for Electronic Arts Need for Speed III with dynamic lighting, streaming audio, and flying text.

>> Users can paint the skin of a car in this site for the NASCAR Revolution 3D Paint Program for Electronic Arts.

01 02 03 04 05 06 07 08 **09** 10 11 12 13 14

09
Freestyle Interactive

Freestyle Interactive is the creation of three self-described computer science geeks who met while playing an interactive game online, of course. They then hooked up at a party offline and decided to create a company that focuses on building Java-based Web effects and database libraries. Two years later, with a portfolio filled with work for Fortune 500 companies, Freestyle is not only defining the next generation of online communication and content, they're building it.

"Our design team fully understands the Internet archetype and is able to unleash its creativity while adhering to the technical limitations of today's banners and file-size restrictions," says CEO Karim Sanjabi. "The role of designers in the Freestyle creative process is to foster imagination while applying technical expertise to the finished product."

Freestyle designers, who are classically trained at leading multimedia and graphic design institutions, have proven themselves under fire with major projects for clients such as Sony Online Entertainment, Electronic Arts, Warner Brothers, Nintendo, Nestle, and Intel. Its work runs the gamut from registration forms and banner tool-kit systems to multi-player games, special effects, and digital advertising and promotional communications.

"My team is incessantly pushing the envelope in Internet design," says creative director Rob Aguilar. "We have to innovate in order to stay competitive." Aguilar says that thinking strategically about consumer behavior is the most distinctive difference in designing Web-based solutions versus designing offline media.

Web designers face formidable challenges, Sanjabi points out. First, the industry is relatively young and in uncharted territory. "More importantly," he continues, "most prospective clients aren't attuned to the importance—and the enormous difficulty—of establishing a freestanding brand identity on the Web."

Despite its geek roots and mastery of rich-media architecture, Freestyle's partners recognize that its clients need more then technological expertise. "When competition for recognition is paramount, companies need a creative interactive design partner that can push them and their ideas further," Aguilar says. "Great ideas, after all, are the rarest commodity in business."

>> A highly animated banner for Nintendo's Gameboy upholds the brand's dynamic image with stunning visuals under 12K.

>> A lightweight interactive Java banner provides a jarring, photorealistic rendition of a comet hitting Earth in this banner for Paramount Pictures Deep Impact.

>> A custom Java applet seamlessly combines click-through functionality with intensive image effects on the Warner Bros. online Hip Clips site.

Interactive partner for GGC&Y, San Francisco / **Address.**58 2nd St., San Francisco CA 94105 / **Voice.**1.800.460.3693 /
E-mail. sales@freestyleinteractive.com / **Web Site.**www.freestyleinteractive.com / **Executives.**Karim Sanjabi.CEO, Rob Aguilar.Creative Director

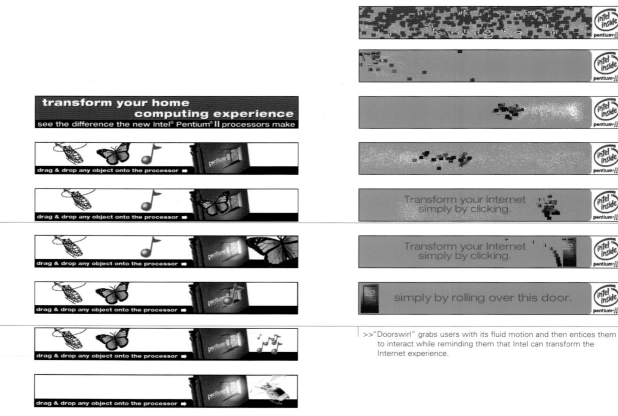

>>"Doorswirl" grabs users with its fluid motion and then entices them
to interact while reminding them that Intel can transform the
Internet experience.

>> The "dragmorph" banner first engages the user with smooth animation
and a nice lens flare effect and then invites them to drag objects onto
a Pentium II to see what a difference the new processor makes.

Marketing Objective:

Break through advertising clutter, generating ad awareness levels above and beyond those seen with standard animated GIFs.

Creative Strategy:

The animated effects are designed to stand out while drawing attention to the "Intel Inside" logo.

Media Placement:

Sites like Wired Digital's WebMonkey that reach technologically sophisticated users.

>> A plasma-streaming effect immediately grabs the user's attention.

>> An "Immediate Response" banner, this Java-based ad features real-time special effects and collects registration information.

President & CEO.Karim Sanjabi / **Chief Technical Officer.**Stephen Von Worley / **Account Director.**Rand Ragusa / **Software Engineer.**Keith Neal

Tools Used.Adobe Photoshop / Sun Microsystems Java Development Kit / Vim / Perl

15 16 17 18 19 20 21 22 23 24 25 26 27 28

>> Sun Microsystems

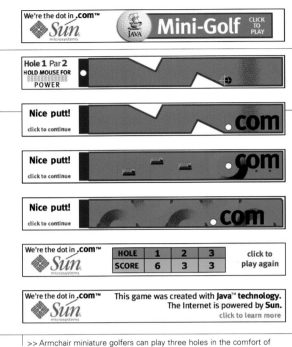

>> Armchair miniature golfers can play three holes in the comfort of their monitor.

>> The BreakThrough banner offers a straightforward challenge and message, showcasing Sun and Java in the process.

>> The Shufflepuck banner also makes the case for Java technology.

President & CEO. Karim Sanjabi / **Chief Technical Officer.** Stephen Von Worley / **Account Director.** Rand Ragusa / **Software Engineer.** Keith Neal / **From Left Field (Freestyle's partner on this project): Creative Director.** Fred Schwartz / **ACD & Copywriter.** Jeff Heath / **Art Directors.** Dylan DiBona, Brian Murphy / **Account Supervisor.** Lisa Cross / **Associate Media Director.** Sara Lamb / **Media Planner.** Katie Cushmore

| 01 | 02 | 03 | 04 | 05 | 06 | 07 | 08 | 09 | 10 | 11 | 12 | 13 | 14 |

Marketing Objective:

Raise the awareness of Sun's role with the Internet to a new level in support of the "we put the dot in .com" offline campaign.

Creative Strategy:

Demonstrate in real-time that Sun is empowering the Net through three classic games that can be played within a banner: Minigolf, Shufflepuck, and Breakthrough.

Media Placement:

Target developers who frequent sites that cover high tech.

Tools used. Adobe Photoshop / Sun Microsystems Java Development Kit / Vim / Perl

15 16 17 18 19 20 21 22 23 24 25 26 27

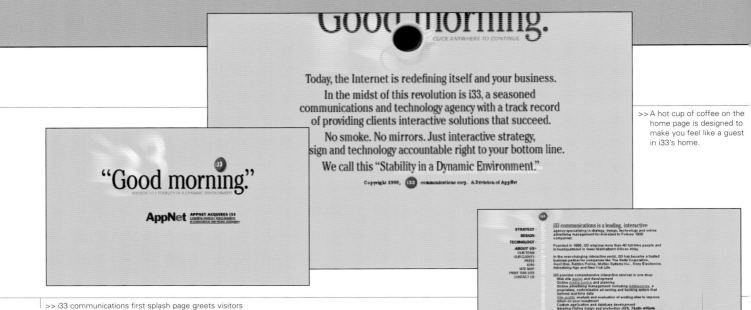

"Good morning."
VERSION 3.0 | STABILITY IN A DYNAMIC ENVIRONMENT

AppNet APPNET ACQUIRES i33
Leading agency kang/leading
e-commerce services company

Good morning.
CLICK ANYWHERE TO CONTINUE.

Today, the Internet is redefining itself and your business.
In the midst of this revolution is i33, a seasoned
communications and technology agency with a track record
of providing clients interactive solutions that succeed.
No smoke. No mirrors. Just interactive strategy,
sign and technology accountable right to your bottom line.
We call this "Stability in a Dynamic Environment."

Copyright 1998, i33 communications corp. A Division of AppNet

>> A hot cup of coffee on the
home page is designed to
make you feel like a guest
in i33's home.

>> i33 communications first splash page greets visitors
with a warm and friendly, "Good Morning."

>> A second splash page invites you to learn more about the agency.

Accountability Is Everything

> *Effective online advertising delivers quantifiable results accountable right to your bottom line.*

> *There are two things you should demand from your interactive partner: accountability and results.*

> *Generate consumer interest and activity and achieve branding as a natural extension of efficient ROI-centric marketing.*

01 02 03 04 05 06 07 08 09 **10** 11 12 13 14

i33 communications

The online consumer votes with his mouse, says Drew Rayman, i33 communications' chief executive, and that's why direct response must drive creative design. The interactive nature of the medium enables consumers to communicate with and experience the brand. Whether a marketer's goal is building a brand, generating leads, or increasing sales, i33 is able to measure which advertising creative and placements are achieving the desired online marketing goals.

Founded in 1995, i33 communications, a division of AppNet, Inc., is a leading interactive agency specializing in online return on investment. It provides a comprehensive set of services, including Web site design and development, online ROI media buying and planning, and the AdMaximize ROI ad tracking service. "All interactive agencies claim to develop great creative," Rayman says. "At i33, we prove what great creative is. When it comes to online advertising, accountability is everything." The agency has developed AdMaximize, an Internet-based service that allows advertisers to measure real-time return on their marketing investment and ensures that i33 is designing the most effective creative possible.

Launched in December 1997, AdMaximize instantly tracks advertising performance and produces customized reports based on a client's tracking needs. i33 optimizes the client's media buys and ad designs weekly. "Most importantly, AdMaximize empowers the media team to analyze and maximize ROI by tracking not just ad click-throughs," Rayman says, "but also verifiable consumer brand interactions, leads, and sales."

i33 identifies the tracking and reporting needs of each client and builds AdMaximize to reflect its individual business model. It discovers what creative resonates best with the target audience through testing and its extensive knowledge base. By tracking the users' interactions—their hands-on experience of the client's brand—i33 continually refines a campaign's creative and positioning. "We have tested what works and learned how to develop strong, winning creative," Rayman says. "Whatever works, works well. Whether it's humor, simplicity, color palettes, or sophistication, we learn what engages customers during a campaign. The right ad in the right place at the right time brings the client maximum results."

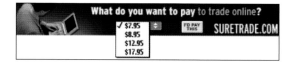

>> Utilizing HTML, this pull-down banner for SURETRADE encourages user interaction with the SURETRADE.COM brand.

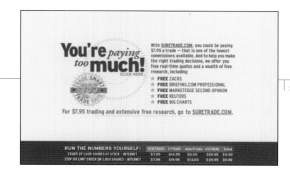

>> Users who select a commission price other than $7.95 link to this jump page promoting SURETRADE.COM's competitive price advantage.

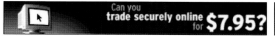

>> A smart, sophisticated look based on key value propositions of commission price, confidence, and security.

A division of AppNet,Inc.**Address.**15 West 26th Street, 9th Floor, New York NY 10010 / **Voice.**212 448 0333 / **Fax.**212 481 7909 /
E-Mail.david@i33.com / **Web Site.** www.i33.com / **Executives.**Drew Rayman.Chief Executive Officer, David Raup.Creative Director

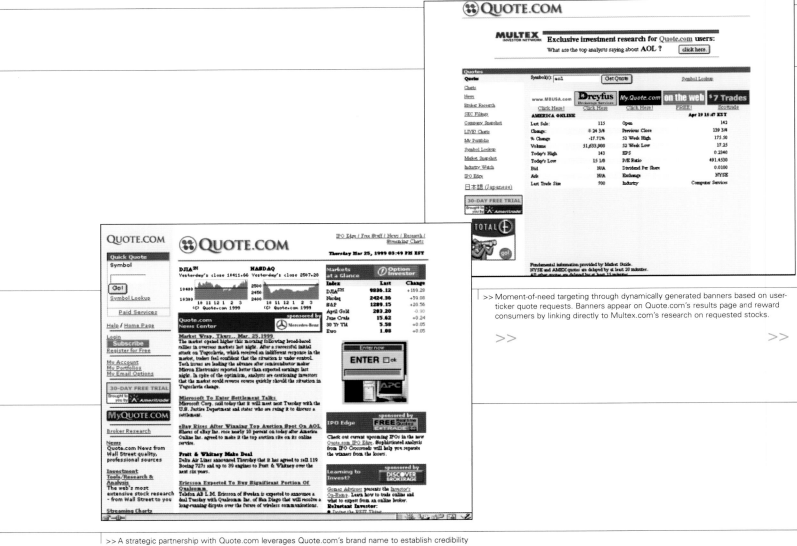

>> Moment-of-need targeting through dynamically generated banners based on user-ticker quote requests. Banners appear on Quote.com's results page and reward consumers by linking directly to Multex.com's research on requested stocks.

>> A strategic partnership with Quote.com leverages Quote.com's brand name to establish credibility with prospective Multex.com consumers. When users type ticker symbols in Quick Quote section (in this case, AOL),they receive dynamically generated banners based on their requests.

Design/Motion Graphics.Mike Mazar, Andrew Skey / **Producer.**Michael Simanoff
Tools Used.Adobe Photoshop / Adobe Illustrator / Adobe After Effects / Equilibrium DeBabelizer / Macromedia Fireworks / GifBuilder / i33's AdMaximize

01　02　03　04　05　06　07　08　09　**10**　11　12　13　14

Marketing Objective:

Introduce Multex.com brand and service to affluent investor community and develop co-brand services to enhance user loyalty. The Multex campaign is designed to blend mission-critical technology with moment-of-need targeting to maximize ROI.

Creative Strategy:

Proprietary technology delivers dynamically generated banners to investors based on user-ticker quote requests. Campaign themes are based on Multex.com's value propositions of breadth of research and empowerment.

Media Placement:

Leveraged credibility of Quote.com brand to build Multex.com's user base. Decreased cost-per-member-acquisition rates five-fold by linking user need to Multex.com's offerings.

>> Demonstration of Multex.com's ability to empower the serious investor with more than 200,000 investment research reports.
A sophisticated, fluid animation of the stock ticker graphic enhances the credibility of the previously unknown Multex.com brand.

>> Utilizes mailbox and product imagery to demonstrate the unique selling proposition of adding pictures to e-mail with ease.

>> Keyword Sony established presence as an AOL content resource, providing users with the ability to query the brand with a simple keystroke.

>> Designed to appear as a how-to-add-pictures-to-your-email resource, this leverages the power of the Sony brand with strong call to action and simple messaging.

Images courtesy of Sony Electronics Inc.

01 02 03 04 05 06 07 08 09 **10** 11 12 13 14

Marketing Objective:

Test America Online (AOL) as an e-commerce vehicle for Sony's first e-commerce initiative by selling floppy-disk camera through a targeted e-commerce program.

Creative Strategy:

Position camera in banners and on AOL site as a utility specifically for AOL users. Banners are designed to appear as content and guide to using AOL resources.

Media Placement:

Through creative and media optimization, click-through rates doubled and cost-per-sale decreased by 50% in less than two weeks.

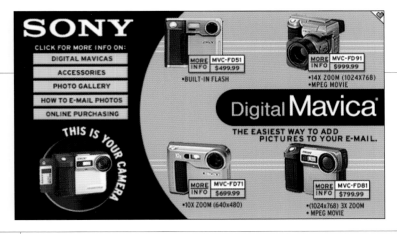

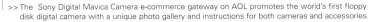

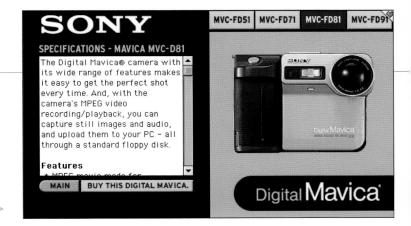

>> The Sony Digital Mavica Camera e-commerce gateway on AOL promotes the world's first floppy disk digital camera with a unique photo gallery and instructions for both cameras and accessories.

>> This page displays product information in a simple and easy-to-use format, allowing consumers to make educated purchasing decisions by scrolling through product features, specifications, and accessories.

Producer.Brian Hack / Art/Design Director.Marina Cindolo / AOL Developer.Jane Hansen
Tools Used.Adobe Photoshop / Adobe Illustrator / Equilibrium DeBabelizer

contact@ideutsch.com

jobs@ideutsch.com

iDeutsch

>> Like the cobbler's children, iDeutsch's own site is not its first priority.

Leveraging Brands
with Technology

> *Leverage the brand with technology, don't leverage technology with the brand.*

> *it's not about a Web site, it's about what's right for the brand.*

> *Don't build Web sites, build customer relationships.*

>> This three-frame animated GIF banner for IKEA promotes a free brochure for businesses and home-office workers in need of furnishings.

01　02　03　04　05　06　07　08　09　10　**11**　12　13　14

12
iDeutsch

iDeutsch grew out of Deutsch, *Advertising Age's* 1998 Agency of the Year, to service the interactive needs of its existing client base. In one year, it has grown from a handful of staff members to nearly 60 people serving clients on both coasts. It also has moved beyond the existing Deutsch client base to include new clients such as Brittanica.com, and was ranked No. 32 in *Adweek's* Top 50 Interactive Ad Agencies for 1999.

The Tanqueray Link Classics campaign on the pages that follow is one of the most engaging ads yet created for the Web. It won, among other kudos, the 1999 Gold @d-Tech award for best branding campaign. Developed with Thinking Media, it is a prime example of an execution that, in the words of iDeutsch creative director Keith Ciampa, "brings the message to the online community in a fresh and relevant way." Indeed, it brings the entire brand experience to the user from within the banner itself. It also creates good will for the eight partner sites that share the first tee and each sponsor one additional hole of the nine-hole course.

"We've created a partnership that benefits both Tanqueray and the partner sites," says Laura Mete, media supervisor for iDeutsch. "Tanqueray receives exposure to their game and player perks; each partner site receives traffic that originates from one of the seven other game access points. "

iDeutsch uses account planners to glean insight into a brand's consumers, and its creative flows from that perspective. "If you look at our work you won't say, 'that's iDeutsch, that's iDeutsch, that's iDeutsch'; you'll say, 'that's Britannica.com, that's IKEA, that's Mitsubishi,' " says Adam Levine, iDeutsch senior vice president of interactive client services. "We open up the voice of the brand and let it speak for itself. Three words that we use are 'human spoken here.'"

Levine says that interactive designers need to be even more conscientious of the end user than creatives working in other media. "There are things that we have to consider, whether it's netiquette, the interface, or usability that ultimately impact the design." The rules for television and print are already well-established. "Everyone knows how people read and that a headline grabs your attention," Levine says. "On the Web, it's all so new. And even though there are some rules, you have to be careful that when you're breaking them, you're doing so within the voice of the brand and not against the voice of the consumer."

Ultimately, the design must flow from the brand the way that the dancer becomes the dance. "One of our creative guys used to say that the mark of a good technologist is that you don't see his fingerprints," Levine says. "And I say the same thing about a good designer. You don't see his paintbrush."

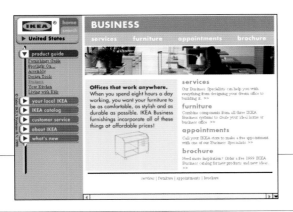

>> The banner also drives users - as many as 13 percent of them - to this sitelet, which features a couponing campaign.

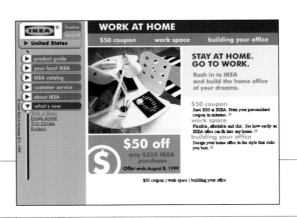

>> Registration is required to get a coupon that you can use when visiting an IKEA store.

Address. 111 Eighth Ave., 14th Floor, New York NY 10011 / **Voice.** 212 981 7600 / **Fax.** 212 981 7537 / **E-mail.** adam_levine@ideutsch.com / **Web Site.** www.interactivedeutsch.com / **Personnel.** Adam Levine. Senior Vice President, Interactive Client Services

>> Tanqueray

>> iDeutsch uses ActiveAds created by Thinking Media to offer users a fully playable nine-hole golf course.

>> The initial banner loads in a file of only 5kb, enabling the partner sites to run it without slowing down delivery of their Web pages.

>> ActiveTrack allows iDeutsch to monitor results in real time and to use metrics, like the amount of time surfers spent playing the game (usually from three to nine minutes).

Marketing Objective:

Reinforce the brand strategy for Tanqueray in a way that makes sense for the Internet by giving people a chance to interact with the brand.

Creative Strategy:

Engage the consumer with the Tanqueray brand in an entertaining way without requiring the participant to click through to a separate Web site — the entire brand experience is contained within the banner.

Media Placement:

Receive from each site ad impressions for the Hole #1 banner of the game, and perks for registered players. In return, each site becomes part of the tournament and gets to co-sponsor, with Tanqueray, one of the subsequent holes.

>> You can start the course at the sites of any one of eight sponsors - in this case The Sporting News and The Market - but all players finish the course on Tanqueray.Com.

>> "ActiveAds & ActiveTrack make it possible to go beyond the blunt instrument of click-through and create an experience that brings brand interaction to the surfer," says Owen Davis, managing director of Thinking Media.

>> More than 8 percent of 12,000 players play all nine holes and fill in the form for the perks, which is significantly higher than the 2-3 percent response rate that most direct offers achieve.

01 02 03 04 05 06 07 08 09 10 **11** 12 13 14

Tanqueray Gin and Tonic

Previous

1 1/2 oz. Tanqueray Gin
4 oz. Tonic Water

Next

Tanqueray
Mini Bar

>> "We want to bring Tanqueray to our target consumers in a way that makes sense for the
Internet," says RoseMarie Ferraro, brand manager for Tanqueray. "We're attracting people
that regularly visit the partner sites and giving them a chance to interact with the brand.

Art Director.David Skokna / **Writer.**Suzanne Darmory / **Programmers(Thinking Media).**Jason Snyder, Vid Jain / **Producer.**Gene Liebel
Tools Used.ActiveAds / ActiveTrack / Java

15 16 17 18 19 20 21 22 23 24 25 26 27 28

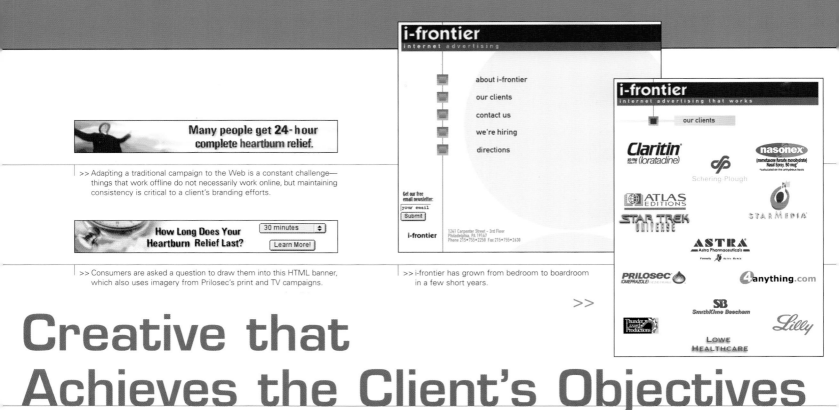

Many people get 24-hour complete heartburn relief.

>> Adapting a traditional campaign to the Web is a constant challenge—things that work offline do not necessarily work online, but maintaining consistency is critical to a client's branding efforts.

How Long Does Your Heartburn Relief Last? | 30 minutes | Learn More!

>> Consumers are asked a question to draw them into this HTML banner, which also uses imagery from Prilosec's print and TV campaigns.

i-frontier
internet advertising

about i-frontier
our clients
contact us
we're hiring
directions

Get our free
email newsletter:
your email
Submit

i-frontier

1241 Carpenter Street – 3rd Floor
Philadelphia, PA 19147
Phone 215•755•2250 Fax 215•755•2630

>> i-frontier has grown from bedroom to boardroom in a few short years.

>>

i-frontier
internet advertising that works

our clients

Claritin (loratadine) · nasonex (mometasone furoate monohydrate) Nasal Spray, 50 mcg · Schering-Plough · ATLAS EDITIONS · STARMEDIA · STAR TREK UNIVERSE · ASTRA Astra Pharmaceuticals · PRILOSEC (OMEPRAZOLE) · 4anything.com · SB SmithKline Beecham · Thunder Lizard Productions · Lilly · LOWE HEALTHCARE

Creative that Achieves the Client's Objectives

> Designing for the Web is a struggle of quality versus efficiency.

> It's the subconscious acknowledgment of what is to come—what the future holds—that excites.

> If getting the consumer to interact with the brand is the Holy Grail of marketing, online advertising is the beginning of a successful crusade.

Stop the madness of searching online.
Find it here: [] Go

>> This HTML banner for 4anything.com integrates elements from the client's broadcast campaign and focuses on user frustration with online searching by implying that it's usually a "wild goose chase."

>>

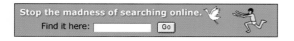

>> The player chases a goose around in this banner for 4anything.com built with Macromedia's Flash technology.

01 02 03 04 05 06 07 08 09 10 11 **12** 13 14

12
i-frontier

i-frontier began in President Brad Aronson's bedroom in February, 1996. By building a strong team of creative, media, and account people, i-frontier has grown to become one of the country's leading Internet advertising agencies, with clients including the allergy drug Claritin, Star Trek Universe, StarMedia Network, SmithKline Beecham, AstraZeneca (Prilosec), and others.

At i-frontier, the role of the creative team goes beyond advertising executions. The creative team is involved in a client's strategic planning long before any advertising is actually developed, working with the account and media teams to ensure that strategies and messaging can be executed to deliver results. "Creative is only as good as the results it generates, and that isn't always an easy task," Aronson says. "Involving the creative team in the process from the beginning guarantees the best chance of success."

Senior art director Robby Garfinkel says that designing for the Web is not easy. It is a practice, as is all commercial design, of limitations. "Quality design is always a balancing act," he says. "However, quality is not always the issue. Excellent creative has performed poorly, just as poor creative has performed phenomenally."

i-frontier believes that the principles of advertising for the Internet are the same as they are for other media: It's not how good an ad looks and behaves, but how well it communicates. The agency's creative team recognizes the technological differences between the Web and other media, of course, and focuses on the advantages, while downplaying the disadvantages as much as possible. "The Web does not yet have the grandeur of film, the pervasiveness of television, the clarity and tactile preciousness of print, or the emotional power of all three," says Garfinkel. "The Web is the scene of the crime, where quality is the victim and bandwidth is the culprit. Designing for the Web is a struggle of quality versus efficiency. It is difficult to provide a rich experience for the user under such conditions."

i-frontier's design focuses on a benefit the Web has over film, television, and print: interactivity. By using HTML-forms, JavaScript, Java, Macromedia's Flash, and other technologies, it is possible to allow the user some form of interaction beyond simple point and click. Research shows that net advertising that engages the user through interaction dramatically exceeds the performance of static or animated banners. For the most part, these interactions are little more than novelties. But some of this technology does allow for a more interesting and convenient experience, such as completing a purchase from within the banner.

"Using interactivity boosts performance, period. The coming broadband revolution will allow us to truly engage the user and enrich his or her experience," says creative director Jeremy Lockhorn. Garfinkel agrees with Lockhorn that interactivity should ideally serve a purpose. He also points out that restrictions aren't limitations as much as they are challenges. "Design is as much a matter of problem-solving as it is a formal exercise," says Garfinkel. "Yes, the role of design ultimately is to communicate. However, the role of the designer is much more complicated: A good designer fulfills client goals. A bad designer fulfills only his or her own desires. A great designer is one who can fulfill both."

Please Join **Friends** and **Colleagues** during **DDW**®	at the **Wonders** of **Life** Pavillion

>> This animated GIF is for Astra Pharmaceuticals, the makers of Prilosec, to attract physicians and professionals to its booth at a convention. It suggests a fun atmosphere without using images or logos (a restraint).

take the **GI Challenge**	Sponsored by **Astra Pharmaceuticals** click here for other activities @ DDW®!

>> The look and feel is contemporary, with a retro color-scheme that also suggests the sun-and-sand quality of the convention held in Florida.

15 16 17 18 19 20 21 22 23 24 25 26 27 28

Address.1241 Carpenter Street, Philadelphia PA 19147 / **Voice.**215 755 2250 / **Fax.**215 755 2630 / **E-mail.**info@i-frontier.com / **Web Site.**www.i-frontier.com / **Executives.**Brad Aronson.President, Jeremy Lockhorn.Creative Director, Robby Garfinkel.Senior Art Director

>>

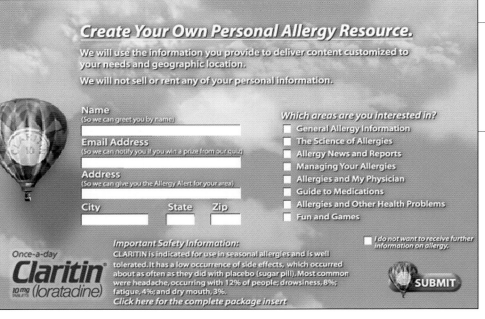

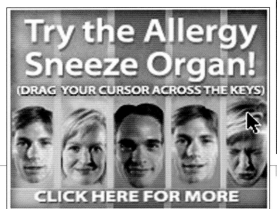

>> As you mouse over the different faces, they sneeze at variable pitches in this rich-media ad (Macromedia's Flash) designed for the broadband capabilities of the @home network.

>> This form, which follows a Sneeze Organ click-through, uses Macromedia's Shockwave technology because it can provide a background with fluid animation. The user has the opportunity to request customized allergy content, while providing contact information to Claritin.

>>

>> HTML drop-downs entice the viewer to interact in this banner from a campaign that focuses on outdoor activities the seasonal allergy sufferer might miss.

Creative Director.Jeremy Lockhorn / **Designer.**Adam Embick
Tools Used.Adobe Photoshop / Macromedia Fireworks / Macromedia Director / Macromedia Flash / Shockwave

01 02 03 04 05 06 07 08 09 10 11 **12** 13 14

Marketing Objective:

To drive allergy sufferers to the Claritin site, which is designed to educate and encourage visitors to speak with their doctors about the medication.

Creative Strategy:

Pharmaceutical direct-to-consumer advertising is highly regulated—if you mention the brand name of the product and make a claim, you must also include prescribing information and the most noticeable side effects. Squeezing so much information into a standard-sized ad is nearly impossible. i-frontier's solution is two-tiered: 1. use as many non-standard placements as possible to push branding efforts as well as response; 2. use non-branded banners that focus on suffering as it relates to seasonal allergy symptoms.

Media Placement:

Primarily large sponsorship buys focusing on content and tight integration with sites.

>> This modification of the Yahoo! logo is part of a weather sponsorship in which Claritin provided content for Yahoo!'s pollen/allergy area.

>>

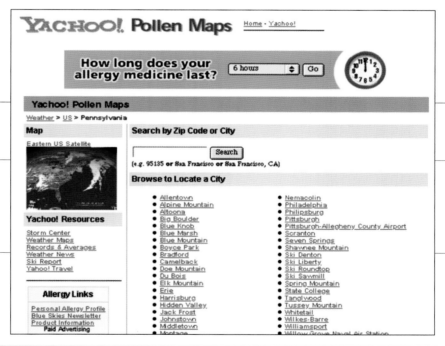

>> The breadth of the Claritin Yahoo! sponsorship is evident in the reworked Yahoo! header, the standard banner at top, the 120x60 button next to the search box, and the set of "allergy links" on the left-hand side.

>> Star Trek Universe Cards

>> Fans interact by seeing if they know the answer to the trivia question in this banner that resembles the Star Trek interface from the TV show.

>> When the answer is entered, fans are sent to a page that praises or chastises them— and either way suggests they get the Trek cards.

Creative Director. Arvin Casas
Tools Used. Adobe Photoshop / Macromedia Fireworks / BBEdit

Courtesy of Paramount Pictures Star Trek: The Next Generation
Copyright © 1997 by Paramount Pictures. All Rights Reserved.

01 02 03 04 05 06 07 08 09 10 11 **12** 13 14

Marketing Objective:

Generate leads for the Star Trek Universe card club.

Creative Strategy:

The creative uses Star Trek imagery and fonts that are instantly recognizable to Star Trek fans and drive users to request the first set of cards.

Media Placement:

Star Trek and science-fiction-related sites and other sites where advertising can be purchased on a cost-per-lead basis.

>>

>> This banner is also instantly recognizable as Trek-related; fans can type in the code to stop the destruct sequence, but the ship always blows up.

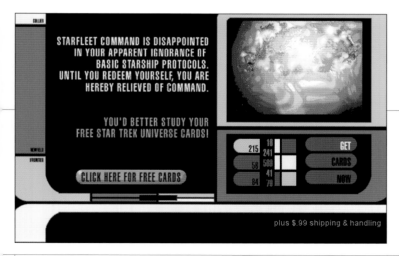

>>

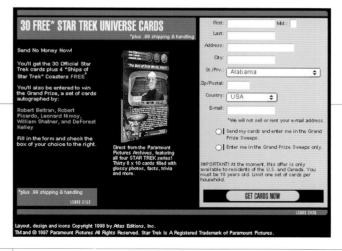

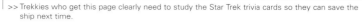

>> Trekkies who get this page clearly need to study the Star Trek trivia cards so they can save the ship next time.

>> This interstitial ad pops up when consumers are waiting for software to download. Since they've already registered at the page, it's very easy to order because the fields are populated with their contact information.

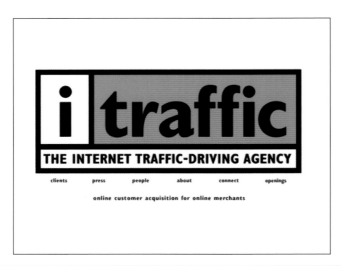

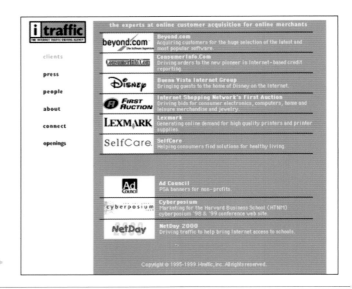

>> i-traffic's home page and a client list page.

Turning Surfers into Shoppers;
Browsers into Buyers

> *Destroy what bores you on sight.*

> *Fast and simple is better than slow and complex.*

> *One-to-one marketing is the Holy Grail of online advertising.*

i-traffic

Scott Heiferman, then 22, founded i-traffic in early 1995 in a cramped Queens, New York, apartment. i-traffic has since grown to more than 100 staffers with offices on both coasts. The agency's full-service marketing approach focuses solely on e-commerce— or direct marketing—on the Internet. i-traffic provides customized interactive strategic marketing planning, media services, creative executions, and performance analysis.

"Be quick or be dead," says i-traffic creative director Brad Epstein. "That's the key to effective design on the web." i-traffic creatives understand that most people on the Web are there to do something. Find a hotel. Chat. Check a stock price. Comparison shop. Download a picture of Pamela Anderson. "Not one single person anywhere logs on to look at a banner ad," Epstein says.

Television and even print are passive media compared to the Web. The Web engages the active part of a consumer's brain. Unless your design quickly conveys a simple message, your banners aren't worth the free pixels that were used to create them.

i-traffic is turning surfers into shoppers by designing communications that get their attention and then rewards them for giving it. It generates e-commerce for its clients by doing banners that offer content, banners that offer a smile, and banners that offer an offer.

As art directors have gotten better at using the 468 x 60 banner, consumers have gotten better at ignoring them. Going beyond the banner is the new challenge facing anyone trying to reach consumers. i-traffic has found effective ways to communicate in dimensions as varied as 100 x 100 buttons on portals to full-page interstitials.

In every case, the design works because it breaks through the clutter and let consumers know what's in it for them. "Consumers are selfish and why shouldn't they be?" says Epstein. "They work hard for their money and will part with it only if they perceive they're getting a good value."

Art directors creating for the Web have more tools at their disposal than their print counterparts. Besides the usual suspects of color, composition, and typography, Web designers can add animation and interactivity, Epstein points out. "The possibilities are incredible," he says. "But the most successful designs will still be the ones that manage to connect with consumers who have no interest in reading an ad."

>> Banners for client SelfCare on the following pages do not lead directly to this home page, eliminating steps between click and purchase.

>> i-traffic created a sleek banner campaign to interest sports fanatics in membership in ESPN.com's Insider service.

Address.375 West Broadway, New York New York, USA 10012 / **Voice.**212 219 0050 / **E-mail.**info@i-traffic.com / **Web Site.**www.i-traffic.com /
Executives.Scott Heiferman.Founder & CEO, Brad Epstein.Creative Director

>> Ads depicting women in a pleasant setting seemed to communicate best with the target audience.

>> Based on an initial round of banner results, i-traffic found that the highest-performing branding banners were the ones with the least copy.

>> The one-word buttons fading into a beautiful backdrop give the banners an ethereal look that helps to convey an emotional connection with the target.

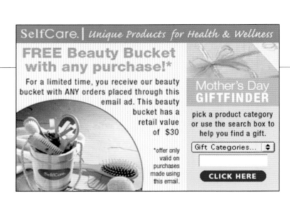

>> This Yahoo e-mailer ad is an interactive mini-site designed to go to four separate landing pages depending upon which pull-down gift option the customer chooses.

Senior Art Director.John Vukusic / **Copywriter.**Justin Kaswan / **Creative Producer.**Vina Lam
Tools Used.Adobe Photoshop / Adobe Illustrator / ImageReady / Gifbuilder / PhotoAnimator / GifWizard / BB Edit

01 02 03 04 05 06 07 08 09 10 11 12 **13** 14

Marketing Objective:

After seeing the communication, the customer should think: "SelfCare brings me products that I haven't seen before. I need to check out their Web site and learn more."

Creative Strategy:

The customer is educated and smart, and tends to shy away from the in-your-face tactics common with traditional Web advertising. She prefers a more emotional approach and is enticed by a smart, concise, direct, and honest message.

Media Placement:

i-traffic targets sites catering to SelfCare's core demographic, including health, shopping, women's, and run-of-site placements.

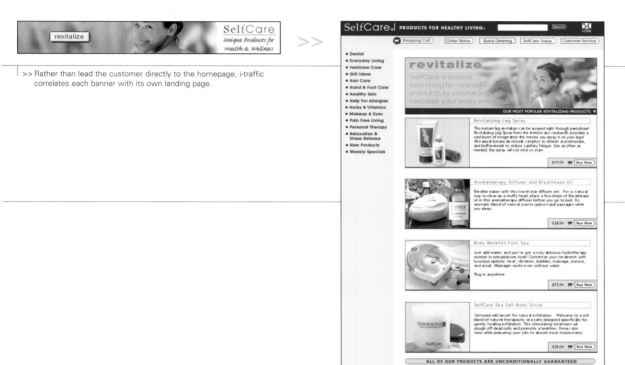

>> Rather than lead the customer directly to the homepage, i-traffic correlates each banner with its own landing page.

>> The "revitalize" banner, for example, leads to this custom-designed landing page, which offers four products related to the word "revitalize". This approach to going beyond the banner eliminates several steps between click and purchase.

Are any of your kids named...

Goose, Babe, or El Duque?

This is the place for you. ESPN INSIDER Click Here.

>> The typography has a fast, sporty feel to it in keeping with ESPN's overall look and feel. Since the written message is strong and concise, i-traffic consciously avoided diluting it with unnecessary graphics and logos.

Do you like hockey?

More than your wife?

This is the place for you. ESPN INSIDER Click Here.

>> The word "hockey" attracts the attention of the sports fanatic and sets the scene, although the first frame is only on for a split second before the fanatic message appears over it.

Creative Director. Brad Epstein / **Senior Art Director.** Doug Miller / **Copywriter.** Andrew Van Hook / **Creative Producer.** Brendan Stanley /
Account Manager. Greg Reichert / **Senior Account Planner.** Ian Schafer
Tools Used. Adobe Photoshop / Adobe Illustrator / ImageReady / BB Edit

| 01 | 02 | 03 | 04 | 05 | 06 | 07 | 08 | 09 | 10 | 11 | 12 | **13** | 14 |

Marketing Objective:

To bring ESPN's unique, irreverent personality to ESPN.com's online marketing efforts; to pique the curiosity of die-hard sports fans (who likely are also ESPN viewers) and encourage them to sign up for ESPN.com's INsider; to increase Insider trial subscriptions.

Creative Strategy:

Use ESPN's irreverent personality to attract the attention of the sports-crazed ESPN viewer.

Media Placement:

Units run on sports content sites as well as ESPN.com, in order to reach the core target audience.

>> The banners lead to an information-packed page designed to turn browser into buyers.

New Online Marketing Opportunities are Emerging.

You know you have to respond. And soon.
What you need is **reliable help.**

So even if you aren't exactly sure
where your future lies yet, contact us.
We can get you there **first.**

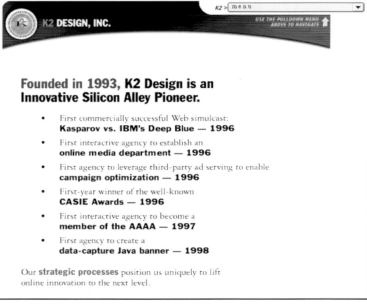

Founded in 1993, K2 Design is an Innovative Silicon Alley Pioneer.

- First commercially successful Web simulcast:
 Kasparov vs. IBM's Deep Blue — 1996
- First interactive agency to establish an
 online media department — 1996
- First agency to leverage third-party ad serving to enable
 campaign optimization — 1996
- First-year winner of the well-known
 CASIE Awards — 1996
- First interactive agency to become a
 member of the AAAA — 1997
- First agency to create a
 data-capture Java banner — 1998

Our **strategic processes** position us uniquely to lift
online innovation to the next level.

One-to-One
Through Sense-and-Respond

> *Through personalization and targeting, online advertising becomes more informative and less intrusive.*

> *Differentiation through the user's experience will be the single factor in any e-commerce success as parity becomes more commonplace.*

> *Design that is not accountable to the business objective is a wasted effort.*

14
K2 Design

K2 Design, born in February 1993 as a creative boutique doing traditional design, quickly established itself in the flourishing interactive arena. Leveraging the experience it gained creating GUIs for CD-ROM projects, K2 Design is a pioneer in high-tech applications. It won a CASIE Award in 1996 for its Kasparov vs. IBM Deep Blue work, which was the first commercially successful Web simulcast. It was also the first agency to create data-capture Java banners.

"Critical to a true one-to-one relationship is a sense-and-respond methodology," says Douglas Cleek, chief creative officer for K2. "Design has a dual responsibility through the user interface and database architecture to fulfill this promise."

Sense-and-respond, Cleek explains, requires a database that profiles and learns from each customer's interaction and responds in a timely manner accordingly. For example, the agency developed a system for the Bellcore Web site that responds to customer-stated preferences and interests by returning related links and published articles that Bellcore engineers want to share with users. K2 also developed a bot called AdHound for ClassifiedWarehouse that alerts users immediately when an item that they've indicated interest in buying becomes available in its extensive database of classified ad listings.

"Online advertisers benefit through the ability to serve up advertisements or offers that are relevant to the user, to optimize impressions, to control the amount of exposure that a particular user may encounter, and to respond accordingly if a user is not responsive to a particular message," Cleek says.

Through trial and experience in user interface development, K2 Design has developed a set of Best Practices guidelines. "Web sites should be designed from the point of view of the user's experience," Cleek says. "User-centric Web design makes things clear, and this clarity yields understanding and appreciation. Sites need to appeal to first-time visitors immediately, and teach users how to operate the site and fulfill expectations, which stimulates further exploration and repeat visits." The role of design is to smoothly integrate the backend software and systems, he says, and to provide a positive, personalized site experience.

K2's media planning begins early in its campaigns. It first outlines benchmarks against which each campaign will be measured, including ad targeting, ad server, and site-acceptance criteria. Its strategy sometimes dictates the use of rich media, as with its campaigns for Standard & Poor's and Bell Atlantic Residential ISDN on the following pages. K2 also often develops jump pages or interstitials for its standard banner campaigns. "They provide an opportunity to move the customer along the decision making process toward a transaction," Cleek says. "Reinforcement of the message and offer, incentives, and the elimination of barriers such as entry fields or hidden content also contribute to the success of the creative executions."

Critical to K2's creative development of an online campaign is a three-tiered foundation: brand positioning, benefits/needs, and a response mechanism. It also considers elements such as branding, file size, color/optimization, technical considerations, placement, offer/incentive, call to action, scalability, personalization, legibility, and timing. K2 refines its creative executions through testing, as in traditional direct marketing. Instantaneous feedback through ad reporting software allows the agency to identify the best executions and placement to achieve its clients' business objectives and a greater ROI.

"The guidelines that we follow are very simplistic, so simplistic that too many site executions fail miserably in delivering on them," Cleek concludes. "But all of them contribute to the overall user experience."

Address.30 Broad Street, 16th Floor, New York NY 10004 / **Voice.**212 301 8800 / **Fax.**212 301 8801 / **E-mail.**info@k2design.com /
Web Site.www.k2design.com / **Executives.**Lynn Fantom.CEO, Douglas Cleek.Chief Creative Officer

>> Invoking doubts about being prepared for the future, this paternalistic approach positions S&P as a secure solution for long-term investing.

>> S&P offers an alternative to the dependency most investors have on their broker for unbiased information.

>> The appeal of "free" quotes here was initially very effective but click rates declined as other sites offered parity products.

>> Enliven technology allows real-time interaction with the S&P database by returning verification back to the banner without going through the Enliven server.

Account Manager.Gina Borriello / **Account Executive.**Abby Berman / **Chief Creative Officer.**Douglas Cleek / **Creative Directors.**Manning Rubin, Bill Heard / **Media Director.**Thomas Hespos / **Multimedia Designer.**Greg Reeves / **Executive Creative Director.**John Givens / **Art Directors.**Ken Braun, Chris Franzese, Doug Jaeger / **Copywriters.**Dan Cronin, Mitch Lemus / **Producer.**Diego Lomanto

01 02 10 04 05 06 07 08 09 10 11 12 13 **14**

Marketing Objective:

Generate trial subscribers and traffic to the Personal Wealth Web site through a 30-day free trial membership, and leverage the Standard & Poor's brand name to the service.

Creative Strategy:

The explosion of online trading presents Standard & Poor's with an opportunity to offer its unbiased expertise to novice online traders through a combination of standard GIF banners and Enliven technology.

Media Placement:

Key messages establish brand relevance on sites that attract the target audience. These are combined with an offer of "30-day free trial subscription," as well as "free quotes," to boost response.

>> Three variations of this extremely effective execution offer the call-to-action right in the main headline.

Tools Used. Adobe Photoshop / Adobe Illustrator / Adobe After Effects / Adobe ImageReady / Gif Builder / Macromedia Director / Macromedia Fireworks / Enliven Plug-in / Metacreations Poser

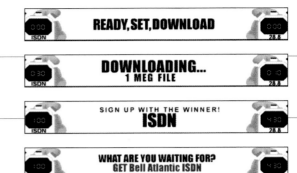

>> A clear comparison of the benefit of ISDN over 28.8 modems for speedily downloading large files.

>> This creative execution clearly illustrates the length of time users have to wait with slower modem speeds.

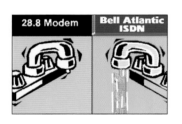
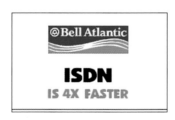

>> The comparative visuals here take advantage of the larger file sizes that can be delivered through the Pointcast network.

>> A temperature gauge makes the comparison between user frustration and modem speeds.

Vice President Account Services.Bob Treuber / **Account Manager.**Gina Borriello / **Creative Director.**Manning Rubin / **Media Director.**Thomas Hespos / **Media Planner.**Jordan Finger /
Multimedia Designer.Greg Reeves / **Executive Creative Director.**John Givens / **Art Directors.**Ken Braun, Chris Franzese, Doug Jaeger / **Copywriter.**Dan Cronin / **Producer.**Diego Lomanto

01 02 10 04 05 06 07 08 09 10 11 12 13 **14**

Marketing Objective:

Generate leads for Bell Atlantic's ISDN sales force for Residential ISDN service, and lower its current direct mail cost of acquisition of $40 per lead.

Creative Strategy:

K2 uses a mixture of GIF banners, Enliven, and rich media with creative executions to compare and highlight the speed advantages of an ISDN line over traditional single-line modem access in the home.

Media Placement:

An offer to get $90 dollars off the installation serves as an incentive for the target audience—SO/HO and Techno Lovers—who may be considering ISDN to act now.

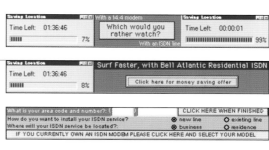

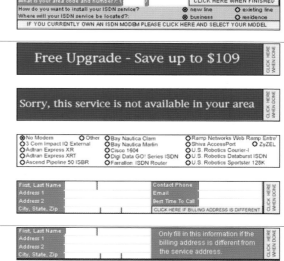

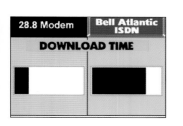

>> This very successful Enliven campaign compares features in an application-like environment, offering the convenience of sign-up and targeting of different offers within different geographic locales.

Tools Used. Adobe Photoshop / Adobe Illustrator / Adobe After Effects / Adobe ImageReady / Gif Builder / Macromedia Director / Macromedia Fireworks / Enliven Plug-in / Metacreations Poser

>> Kabel New Media's services range from management consulting and the development of digital corporate and brand identities to setting up electronic sales and customer loyalty systems.

Taking E-Care of Brands

> *Make your brand fit for interactive dialogue.*

> *The interface with the customer is the key to good design.*

> *Integrated design concepts put substance into colored pixels.*

>> Transactive banners developed for o.tel.o provide all the relevant product information and sales services without the user having to leave a Web site.

>> The multi-functional banners are based on Shockwave or Java, depending on the technical capability of the Web site.

01 02 03 04 05 06 07 08 09 10 11 12 13 14

Kabel New Media

Kabel New Media, providing strategic consulting, planning, and production services in the field of interactive business and communication solutions, is considered a quality leader in the German market. Its Professional Services practice offers strategic consulting as well as the production, technical implementation, support and management of Internet-based solutions. Its Platform Services practice develops Internet portals (advertising, sponsorships, e-commerce) for target groups. The agency sees high profit potential in the platform business; its Web site for ATP Tour *www.atptour.com* is its pilot project.

Kabel obtained all online rights to design, maintain, and market the official Web site of the governing body of men's professional tennis, which it re-launched in March, 1998. Nearly 40 percent of all visitors to the site are from the U.S., but the audience is global—from Chile to Australia to Europe. Kabel sells geographically targeted banner advertisements on the site, as well as sponsorships that are proving to be particularly effective marketing vehicles.

"When I am an advertiser, I use the platform, but I do not intend to convey any close connection between my product and the platform," says Volker Schurr, marketing manager for www.atptour.com. "With sponsoring, the opposite is true. I am spending money to build a connection between my product and the site. My logo becomes part of the Web site."

Since 1996, Mercedes-Benz North America has been the title sponsor of the Mercedes Super 9 series, which comprises the most prestigious events on the ATP Tour. The automobile manufacturer also sponsors a "Special Site" on www.atptour.com that Kabel produced for the Mercedes Super 9 series. A Special Site has its own layout and content, but is closely related to the rest of the site.

"The layout was specifically designed as a combination of both the Mercedes-Benz and the www.atptour.com layout," explains Douglas Lemon, art director at Kabel New Media. "The Mercedes-Benz logo is placed prominently on every single page and the colors complement both the company and the Mercedes Super 9 logos."

The content focuses on the coverage of tournaments in this series, as well as the players competing in them. In addition to editorial content, the Special Site features such sections as Live Scores, Live Stills, Match Highlights, and exclusive sweepstakes. Mercedes also uses this platform for its own promotional activities, posting, for example, PR pictures from events with players driving Mercedes cars, as well as press releases about the company's involvement with tennis.

Schurr points out that in maintaining strong sponsorships, it is vitally important to keep on top of developing technology. Advertisers expect new marketing opportunities for almost every campaign. "It is a great challenge for both sides," says Schurr, "because you develop concepts together. It is completely different from classical marketing in that you cannot go out and offer standard packages. It just does not work. You really have to look at the potential partner and find out what their strategy and image is and then work on an individualized sponsoring offer. There is almost nothing that is not possible."

>> This transactive banner supports a number of integrated functions to make it easier for subscribers to change their telephone company.

>> There is also the option of clicking-through to the advertiser's own Web site to get more information.

| 15 | 16 | 17 | 18 | 19 | 20 | 21 | 22 | 23 | 24 | 25 | 26 | 27 | 28 |

Address.Schulterblatt 58, 20357 Hamburg Germany / **Voice.**+49 432 969 0 / **Fax.**+49 432 969-90 / **E-mail.**info@kabel.de / **Web Site.** www.kabel.de / **Executives.**Peter Kabel.CEO, Arne Habermann.Creative Director

Online Sponsorship of www.atptour.com

>> The ATP Tour site is licensed by Kabel New Media and fully financed through advertising and sponsorships.

>> The animated Mercedes Super 9 banner in the middle of the right side of the page urges users to "See it as it happens on court."

Art Director.Doulas Lemon / **Junior Art Director.**Jan Ridder
Tools Used.Adobe Photoshop / Adobe Imageready / BBedit

Marketing Objective:

The Mercedes Super 9 Special Site <www.ms9.atptour.com> promotes the most important ATP Tour tournament series, the Mercedes Super 9.

Creative Strategy:

News, background information, live coverage, and comprehensive statistics make the site the online platform of choice for this high-class series.

Media Placement:

Mercedes-Benz is a global player, as is the ATP Tour, and extending its engagement to the Internet was a logical way to target a younger group of affluent customers internationally.

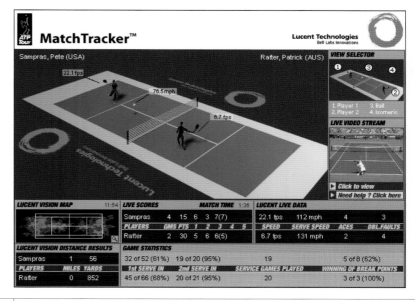

>> Lucent Technology, a technology partner of the ATP Tour, has developed MatchTracker, which displays a whole match as a virtual 3-D live simulation. Users can create their own personalized page to watch the match by selecting small Java applets from various sections to complement the animation: biographical data, key stats, or a chat where they can discuss the play with other fans.

>> Clicking through, viewers see real-time scores as well as other features and statistics.
The Mercedes-Benz banner on the top right leads to the automaker's Web site.

>> Introducing the BMW drivercircle as an innovative, exclusive feature that allows 7Series owners to be just a little faster once again.

>> Shots of the new BMW 3 Series saloon in action within the banner.

01 02 03 04 05 06 07 08 09 10 11 12 13 14

Marketing Objective:

Create strong awareness for the BMW brand and its products within different phases of global marketing campaigns, as well as drive traffic to the BMW.com. site. The drivercircle.com banners create awareness and curiosity in the special target group for a unique after-sales service for BMW 7Series drivers.

Creative Strategy:

Present a dynamic scenario that catches the eye and quickly supports and communicates the brand and product values.

Media Placement:

For campaigns introducing new vehicles, banners are placed on sites where BMW's target customers seek their daily information. The "drivercircle" banners run in financial/business environments.

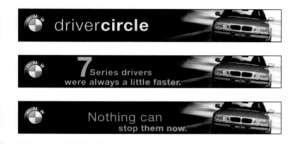

>> Home page of www.bmw.com, the official BMW Web site, which shows all the various facets of the global company and is more ambitious than the many national sites for "the ultimate driving machine."

Art Director. Sandra Schittkowski
Tools Used. Adobe Photoshop / Adobe Imageready / BBedit

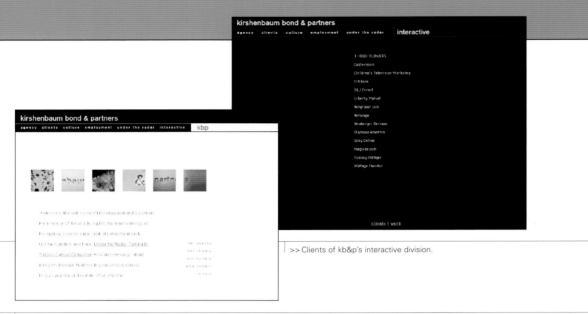

>> Clients of kb&p's interactive division.

>> The agency's homepage incorporates imagery from its offices and sets up a clean, elegant tone for the site.

Gratify the Click

> *Brand values must rule throughout all points of contact, Internet included.*

> *Every click should deliver exactly the experience that the viewer expects, or more.*

> *Viewers won't find what they're supposed to click on if it's buried.*

>> This HTML/CGI banner calculates how much you'll have to shell out to send your kid to college.

kirshenbaum bond & partners

Realizing where the advertising world was moving in 1994, kirshenbaum bond & partners "back-doored" clients onto America Online by partnering with content providers who had permission to feature advertiser links. Those experiences proved that the new medium worked. In early 1995, kb&p built the "official" Snapple Web site (thanking fans that had put up un-official paeans). Later that year, it was one of the pioneers of banner advertising, buying Webspace for Snapple, Citibank, Neuberger Berman funds, and others. Now kb&p is aggressively developing fully integrated communications programs for both Internet and off-line brands on the Internet, as well as in traditional media.

"Brand values must rule throughout all points of contact, Internet included," says Amy VanAarle, creative director/interactive for kirshenbaum bond & partners. "An Internet experience with a brand must be commensurate with the consumer's offline expectation from the brand. Ideally, beyond the consumer's offline expectation."

The interactive division of kirshenbaum bond & partners believes that design plays a critical role in the success of the online advertising campaigns that they create for their clients. All online advertising the agency does, like everything offline, follows one brand "turf"—the look, tone, and visual language of a brand.

As important as it is to extend the brand online, kb&p doesn't believe in putting purely image advertisements online. Every piece of communication online has to give the viewer a compelling reason to want to interact more, to make the jump from impression to click. What's behind that click is of equal value—is the user getting something useful or compelling? Does it make sense? "Gratify the click," says VanAarle. "Make sure that every element that is click-able delivers an experience that results in the viewer feeling that what was served from the click was exactly what they expected—or beyond their expectation."

Excellent design makes this whole experience enriching to consumers, especially since so much of what's on the Web is so profoundly ugly, according to VanAarle. People appreciate a beautiful environment, and the Web is an environment that is (unnecessarily) rarely beautiful. "Cleanliness is next to Godliness," she says. "No one will find what they're supposed to click on if it's buried in your mess on the floor."

>> An animated GIF cleverly conveys that the Olympus Stylus EpicZoom 80 is portable and lightweight.

>> This animated GIF banner uses a propaganda-style image of a flying plane to appeal to hackers, an audience that hates advertising.

>> A talking mouth promotes e-mail, homepages, and chat at theglobe.com.

Address.145 6th Ave., New York NY 10013 / **Voice.**212-633-0080 / **Fax.**212-463-8643 / **Web Site.**www.kb.com /
Executives.Steve Klein.Managing Partner, Amy VanAarle.Creative Director, Interactive

>> Sony's The Station

>> An animated GIF that goes beyond the usual hard-core-gamer schlock to create a compelling, almost evil snapshot of Worm.

>> A challenge to the macho man within.

 >> >> >>

>> Answer the question, "How sexy are you?" and hope for "Red hot."

>> This Java banner draws randomly from a pool of 90 puzzles, assuring that the banner is new almost every time a user sees it.

Creative Director.Amy VanAarle / **Art Directors.**Zoe Balsam, Christiane Gude / **Copywriters.**David Black, Doug Darnell
Tools Used.Adobe Photoshop / Macromedia Fireworks / Java

01 02 03 04 05 06 07 08 09 10 11 12 13 14

Marketing Objective:

Continually drive/increase Web traffic to Sony's The Station site, and hold consumers with a variety of online games.

Creative Strategy:

Although people ages 12–34 use the Web for research, they also like to surf and goof off. Fun, tongue-in-cheek messages, and demonstrations entice them to leave what they're doing and "Come On and Play!" at The Station.

Media Placement:

Banners and sponsored sections on search engines and light entertainment or information sites; keywords on search engines (e.g., Jeopardy, Wheel, games), print in Internet industry publications, and guerrilla advertising such as postcards.

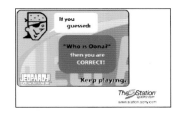
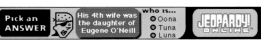
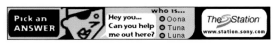

>> An avatar from the game requests help in answering a Jeopardy question.

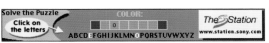
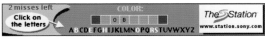

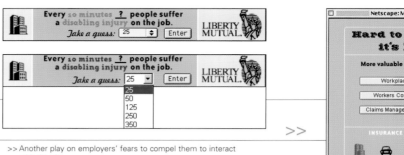

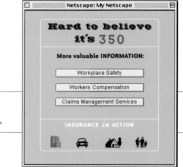

>> Another play on employers' fears to compel them to interact with the site.

>> Consistent with the look and feel of the other banners in the campaign, this animated GIF slyly sneaks in some unappetizing ingredients to attract the attention of the food-processing industry.

>> Humor is used to allay parents' concerns about teen drivers in this animated GIF.

>>

Creative Director. Amy VanAarle / **Art Director.** Zoe Balsam / **Copywriter.** David Black
Tools Used. Adobe Photoshop / Adobe Illustrator / Macromedia Fireworks

Marketing Objective:

To drive traffic to www.libertymutual.com and build awareness through repeated banner exposure on key sites.

Creative Strategy:

Convey that Liberty is a warm, approachable, and honest insurance company that pro-actively helps you live a safer, more secure life.

Media Placement:

Information-rich sites that provide an opportunity to amplify the brand strategy while reaching consumers in the appropriate mindset.

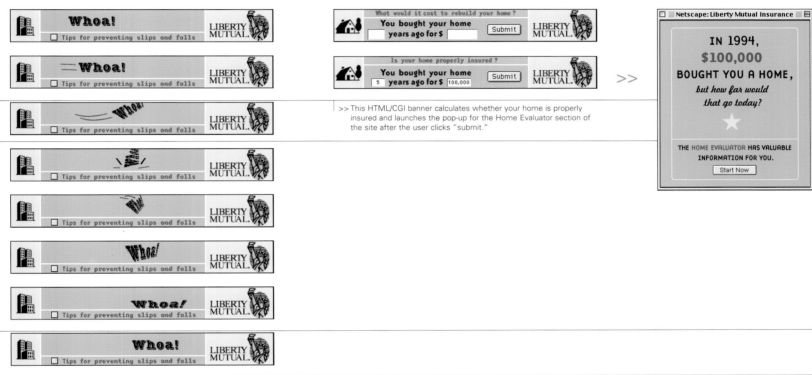

>> This HTML/CGI banner calculates whether your home is properly insured and launches the pop-up for the Home Evaluator section of the site after the user clicks "submit."

>> A slipping "Whoa!" adds a typographical touch of physical humor to highlight a costly concern to construction companies in particular.

>> Don't count LDV BATES among the admakers whose children don't have ads. These imaginative vertical banners are part of an arsenal of house ads the agency has created.

Creating Fans for Brands

> *The digital communication battlefield is not about raw power, it's about smartness.*

> *Don't yell at your target group—think, talk, and occasionally just whisper to one person at a time.*

> *Accountability must enhance creativity, not kill it.*

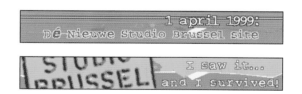

>> This banner for Studio Brussel, the top youth radio station in Belgium, ran only on the launch date of its Web site and was downloaded thousands of times as a collector's item.

>> The vertical format is used to better demonstrate a SCAD dive, which is like a bungi jump without an elastic cord attached to your body.

17
LDV BATES

LDV BATES' interactive department, formed at the end of 1994, was the first within a Belgian advertising agency. It is the largest interactive agency in the country, and has won the most awards. One of six interactive hubs in the global Bates network, it focuses on creativity and both short- and long-term strategy.

"The way you say something is as important as what it is you have to say," says creative director Werner Van Reck. "The tune counts as much as the lyrics."

The breathtaking technological evolution of the Internet is giving art directors and Web designers more possibilities, but it also makes their lives more difficult, Van Reck feels. "Directing and executing ideas is subject to increasingly rigorous choices because there is always the temptation to follow the latest trends," he says.

There's also an ongoing temptation to follow the newest technologies, points out Erwin Jansen, director of the LDV BATES new media department. This presents a dilemma to art directors. They have more possibilities to design interactive executions, but the average user may not have the capability of viewing it. "And isn't it general knowledge that the user is in control on the Web?" Jansen asks rhetorically. He also says there's a temptation to use high-tech executions to gloss over less-innovative creative.

A big plus of designing for traditional media is that they hardly change over time, while the Internet is in constant flux. "You could say it's a challenge to be creative with the medium as well as with the message, but that may call for a new breed of hard-to-find art director who combines top creative skills with up-to-date technological know-how," Jansen says. "On the other hand, it's our belief that great ideas and concepts are unique and can travel over different media."

Designing for the Web has a number of plusses. Direct-marketing messages can be changed on the fly if the desired effect isn't reached. But accountability must enhance creativity, not kill it, Jansen warns. "Never judge a branding campaign by using direct-marketing standards, and never excuse low response by claiming that it was a branding campaign," he says. "Finally, never forget that the effectiveness of the creative is heavily influenced by media placement: You can have the design and the content, you can have the brand, but you also need the context for successful online advertising."

Laws and rules that have existed for decades in traditional advertising are proving more and more to be viable and effective on the Web as well, Van Reck says. "Design and advertising—online as well as offline—are only a means to an end, not an end in themselves," he adds. "Each design element must respect the spirit of the idea, and the essence of the brand. Design, content, and context make up a whole and must therefore use their strengths to state the idea loud and clear."

>> Announcing Virus, a new Belgian newspaper supplement and Web site aimed at youngsters.

>> The campaign for Center Parcs plays with popular phrases in both its French and Dutch executions to express the campaign theme of the "urge to be active and the need for relaxation."

Address.Hangar 26, Rijnkaai 26-27, B- 2000 Antwerp (Belgium) / **Voice.**+32 3 2292929 / **Fax.**+32 3 2292930 / **E-mail.**ldvbates@ldvbates.be / **Web Site.**www.ldvbates.be / **Executives.**Harry Demey.CEO, Erwin Jansen.Managing Director Interactive, Werner Van Reck.Creative Director

>> This banner ran as a tease before the car was launched in the Belgian market. The message "Drive along with the A-Class" pops up as the car moves over the screen.

>> It's not clear to surfers whether they can win an A-Class automobile or a T-shirt, and the only way to find out is to click (it's the T-shirts, but they're very exclusive.)

>> In a new phase of the campaign, people can book an exclusive test drive with the A-Class months before it's actually available, and the call to action is very explicit: "Proefrit? Klik!" ("Test Drive? Click!").

>> The "a" in the word banner is replaced by the picture of the A-Class automobile.

Account Manager.Colette Pauwels / **Mercedes-Benz Belgium.**Yves Callebaut, Marc Badd / **Creative Director.**Werner Van Reck / **Exective Producer, Media Planning & Buying.** Erwin Jansen / **Project Manager, New Media.**Sofie Pintens / **Art Director.**Ivan Moons / **Copywriter.**Stef Selfslagh / **Technical Director.**Koen van Hees / **Web Designers.**Koen van Hees, Kelly Catteeuw, Jonathan Detavernier

Marketing Objective:

Every marketing communication action Mercedes performs gets an online equivalent. The Web is mainly used to support the brand.

Creative Strategy:

All banners are animated, generating click-through rates between 2.5 and 12 percent. Research indicates that price per useful contact (test drives, etc.) is lower than in other media.

Media Placement:

Banners are mostly placed on car-related and general-interest sites (newspapers, banks, etc.) targeted towards upscale males except for the A-Class creative, which also ran on sites attracting youngsters and women.

>> These banners, in Dutch and French, say, "All Mercedes Dealers welcome you to the Mercedes Days from September 9–18."
Click and you're taken to a special section of the Web site with additional information and the capability to find the nearest dealer.

>> This execution launches the Mercedes Nearly New Car concept. The banner leads to exact information on the offer, and to a searchable database of nearly new cars.

>>"Choose now for an extra luxurious C-Class. Your dealer will offer you plenty of free options."
Clicking leads to a micro-site with details, comparison sheets, and the online dealer locator.

>> The bilingual kick-off campaign reads: ¡Mercatorfonds Ö Works of art for your library Ö Order them online.

>> The "a" in the word banner is replaced by the picture of the A-Class automobile.

Marketing Objective:

After building a Web site for Mercatorfonds, one of the world's leading art book publishers, LDV BATES launched a kick-off campaign to get the attention of Web surfers, followed with a concrete offer to inaugurate online bookselling. A third wave of banners promotes specific books.

Creative Strategy:

Generate click-though for online ordering through animation and creative that's appropriate for the subjects themselves as well as the sites the banners appear on. The graphics for the initial campaign are from Mercatorfonds stock; later executions experiment with color and typography.

Media Placement:

Primarily Belgian newspapers and art-related sites. Some portals were used for the kick-off; art and shopping sites for the follow-up; sites for gifts and Belgian IP addresses on Yahoo! for the third wave.

>> As many as 25 variations of a single banner are created so that the colors blend in well with each Web site. This banner says, "How many versions of the water lilies did Monet make?"

>> The "a" in the word banner is replaced by the picture of the A-Class automobile.

>> The "a" in the word banner is replaced by the picture of the A-Class automobile.

>> The "a" in the word banner is replaced by the picture of the A-Class automobile.

Tools Used. Adobe Photoshop / ImageReady

>> The text plays with the Dutch expression, "Is uw frank al gevallen?" (Loose translation: "Do you get it?"). "Frank" is also the name of the Belgian currency. LDV BATES substituted "Euro" for "frank," and the result is "The Euro—do you get it?"

>> This second banner in the campaign says, "Shortly, the Euro will replace the Belgian Frank. In the meantime, we can already practice a bit." Clicking on the banner, you're led to a dedicated Web page where you can change different currencies to the Euro and vice versa.

>> "This button isn't worth a Euro," the banner says. It uses a Javascript, so when you want to click on the "Button" it starts floating over your screen. The only alternative is to click on the Euro coin, which says, "This one does."

>> You can convert from Belgian Frank to Euro and vice versa in the banner itself. Clicking sends you to another page on the EuroWeb site where you can download a special version of the banner for your own site.

Account Executive.Lies Uyttenbroeck / **FVD.**Mieke Van Den Berghe / **Creative Director.**Werner Van Reck / **Executive Producer, Media Planning & and Buying, Concept & Art.**Erwin Jansen / **Copywriter.**Frank Geerts / **Art Direction.**Dominique Vangilbergen / **Web Designer, Technical Director.**Koen van Hees

Marketing Objective:
Branding campaign to make people aware that the Euro is on its way and to make them fans of the new currency.

Creative Strategy:
All the banners use yellow and blue, the European colors, and carry a picture of a Euro coin. The online and offline campaigns use the same copy platform, linking the various executions conceptually.

Media Placement:
Since the Euro concerns everybody, banners run on almost all types of sites with a slight preference for financial areas and pages targeting male professionals.

>> The grand finale of the campaign is a beyond-the-banner execution with the portal site AdValvas, the best known e-brand in Belgium. This is how the site looked before LDV BATES transformed it for a few days.

>> LDV BATES bought the entire homepage, changing the name to Euro AdValvas, and redesigned it to give it a Euro look. The colors are the Euro's yellow and blue. Euro banners run exclusively on the page. When a mouse moves over one of the links, a Euro message pops up (e.g., AdValvas Postman becomes "The Euro Always Rings Twice").

Tools Used. Adobe Photoshop / ImageReady / Macromedia Director / JavaScript

NAVIGATION

Welcome to Left Field
The Advertising Agency

Everyone we meet asks us the same question, "Why Left Field?"
Granted, it's not an obvious name for an agency. But then, neither is our approach to advertising.

Left Field is our way of saying to clients that we will bring you the unexpected and make no apologies for it. It is our way of saying to employees that divergent thinking is everybody's job not just writers and art directors. And finally, it's an expression of our dream to create a place that thinks, acts and feels different than any other place we've ever worked.

So what's in a name? See for yourself.
The navigation is up top.

L E F T F I E L D

>>

Amazon.com
Autoconnect
Biztravel
Cowboy Poetry Gathering
Drugstore.com
ESPN.com
GO Network
Hotmail
ImproveNet
Infoseek
Macy's.com
Sun Microsystems
Virtual Vineyards

Netscape: LEFTFIELD

Portfolio

Left Field is an *oh-my-God-I-can't-believe-I'm-about-to-say-this-but-it's-true-and-well-it's-what-we-do* **integrated marketing communications agency.** *(There, I said it.)*

And since we genuinely believe in integration, all the creatives who work here do so in every medium - print, mail, outdoor, online, whatever. The way we see it, everything's important - postcards, matchbooks, trade show booths - or we wouldn't bother doing it.

The benefit of this is that, in addition to keeping the work consistent, it also keeps the work from dividing the agency into A-teams and B-teams. *(I don't know about you, but I never want to work on or with a B-team.)* So don't be surprised when you see print and mail and whatnot along with all the online. **It's what we do.**

Use the menu to view work by account.
By the way, we're still waiting for our first matchbook assignment...

L E F T F I E L D

>> Since the agency's name isn't e-something, i-something, or something-Web, it feels a need to explain "Why Left Field?"

Marketing for a Wired World

> *If it doesn't move, chances are it won't.*

> *Not everything can be conceptual. But everything should be beautiful.*

> *There's no accounting for taste. Or monitors.*

CHANGE.commerce Sun microsystems

CHANGE.future Sun microsystems

We're the dot in .future Sun microsystems

>> This banner aims to inspire developers to build sites that will change the world (using Sun solutions, of course.)

Left Field

Left Field started out in Michael McMahon's basement a few years ago with three PCs, three folding metal chairs, and a Seattle-based bookseller for a client. That's when its principals established a tradition of buying pizza for the agency every Wednesday. At the time it was a one-pie shop. Now it takes 20 to feed the crew. (By the way, that first client was Amazon.)

"The first role of design in all our work is to make people look," says creative director Fred Schwartz. "That's because the people whose attention we're after are feverishly watching pages load, ready to scroll or click in a blink. At this level, our design is purely visceral—it uses color, shapes, symbols, sound, and motion to capture attention." At the next level, Left Field uses design to communicate its clients' brand attributes: their aesthetics, their values, and their emotional and intellectual underpinnings. In other words, to convey the brand's "look and feel." After that, things start to get really subjective.

"What we're after is truth, rightness, resonance," says Schwartz. "And that differs depending on what medium we're working in." Schwartz cites a *Critique* magazine article by designer Marty Neumeier to make a distinction between creating for the Web versus other media: "Print is a 'slow' medium, one that demands and rewards understanding. By contrast, the Internet is a 'fast' medium, a smash-and-grab tool for transferring information. Both media have their advantages, but it's a mistake to try to endow one with the special virtues of the other."

"On the Web, advertising is extremely disposable," Schwartz continues. "People—clients, consumers, and designers alike—get bored faster than with other media. So much so that it's nearly impossible to adhere to The One Right Way."

But boredom isn't the only enemy of consistency, Schwartz says. Left Field is continually searching for greater responsiveness, forcing it to constantly tweak, augment, and reinvent. Design has to achieve two very different goals: branding and direct response. "It's an uneasy marriage," Schwartz admits, "but one we struggle to make work every day."

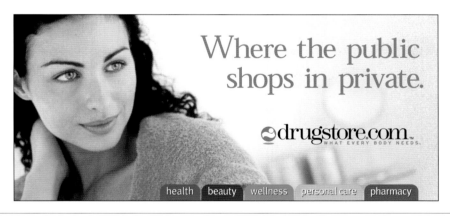

>> Left Field makes it clear that it's an integrated agency, handling "print, mail, and whatnot," as well as online advertising for Web brands like Hotmail.

>> This billboard for Drugstore.com shows the influence of online design on other media, while playing up one of the great benefits of the Web—anonymity.

Address.945 Front Street, San Francisco CA 94111 / **Voice.**415 733 0700 / **Fax.**415 733 0701 / **E-mail.**leftfield@leftfield.net /
Web Site.www.leftfield.net / **Executives.** Kevin Burke.General Manager, Fred Schwartz.Creative Director, Michael McMahon.Strategic Director

>> Amazon.com

>> This HTML-based banner allows the consumer to enter a music or video title to get a results page from Amazon.com.

>> The frustrations of holiday shopping are a natural motivator for shopping at Amazon.com. A faux navigation arrow appears over the Buy, Wrap, Ship button.

>> As the button depresses, a wrapped book appears...

>> ...and zooms across the banner.

>> Amazon.com created a special section devoted to the latest episode in the Star Wars saga. The banner rotates through the some of the characters from the wildly popular series.

Art Director/ACD.Paula Grech Mills / **Copywriter.**Greg Mills / **Art Director.**Wayne Lee / **Copywriter/ACD.**Jeff Heath / **DTHML Coding.**David Morse
Tools used.Adobe Photoshop / GIFBuilder

Marketing Objective:

To introduce consumers to various offerings that move beyond Amazon.com's original competency—selling books online.

Creative Strategy:

Although these banners aren't strictly a campaign, they do have a design element in common: the approximation of a user interface, something that has proved successful in inviting consumers to interact with the banner.

Media Strategy:

Since Amazon.com's customer base is extremely broad—really anyone who shops on the Web—the banners are scattered far and wide among general interest sites and portals.

>> Users select a genre to hear a 30-second RealAudio snippet of the most popular artist in the category.

>> This banner uses DHTML, giving the user a high level of interactivity.

>> As the user mouses over the banner, each tab serves up a list of titles.

>> The user can then select a title and the appropriate merchandising page is served.

>> This banner appeals to the music collector by promoting one of Miles Davis' top selling titles.

>> Plus the promise of a whole lot more.

>> The color palate gives the banner the look and feel of classic jazz album covers of the be-bop era.

Bridges Over Troubled Water

> *The only boundaries are those already created in our minds.*

> *If you want to do it, do it properly.*

> *Win or vanish.*

>> Electric sparks in the logo dramatize the message that this oil company now offers household electricity.

>> Push "fast forward" to get to this new credit card.

19
Leo Burnett Interaktiv

As a fully integrated division of the Leo Burnett agency in Oslo, Norway, Leo Burnett Interaktiv works with clients from all over the world to create marketing solutions for brands. Its global clients include Fujitsu, Cisco Systems, Statoil, and Tennant; its domestic accounts include NetCom, K-Bank, and Rica Hotels. "You might call us Norway's hardest-working interactive department," says creative director Eystein Ruud. "The only boundaries we encounter are those already created in our minds."

New Internet businesses are created every day, Ruud points out. So are new technological solutions. Against this backdrop of constant change, it's important to create digital solutions that are both stable and meaningful for existing clients. "It's win or vanish. It's that simple," he says. "To figure out how, that's the hard part."

Interactive technology allows marketers to get to know their customers as well as small-town merchants did before superstores usurped them. "We want you to know what your customers want," Ruud says. "And we want to enable you to keep in touch with the most valuable ones."

Ruud says that Internet designers need to create solutions that users find as easy—and pleasant—as driving an automobile. The design must express brand values at the same time that it gives every customer easy access to relevant information. Admittedly, that's a very complex and difficult task. "If designing for print is like taking candy from kids, interactive design is like breaking into Fort Knox," he concludes.

>> The essence of Leo Burnett crosses borders effortlessly and thrives in new media.

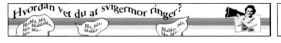

>> If you know who's calling on the telephone, you can avoid talking to your mother-in-law.

>> He's got a strong opinion, in this campaign for Cisco 800 routers, but about what? Click and find out!

>> Simple black-and-white graphics illustrate a campaign for Braathens' new frequent flyer program.

Address.Drammensveien 120 0277 Oslo, Norway / **Voice.**+4722926800 / **Fax.**+4722926944 / **E-mail.**camilla.kristiansen@leoburnett.no
Web Site. www.leoburnett.no / **Executives.**Erik Kristiansen.Managing Director, Eystein Ruud.Creative Director

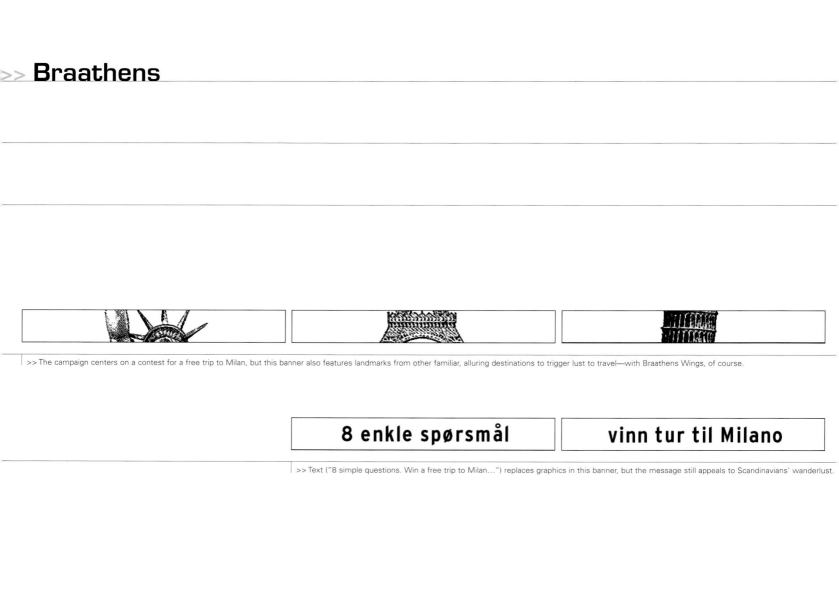

>> The campaign centers on a contest for a free trip to Milan, but this banner also features landmarks from other familiar, alluring destinations to trigger lust to travel—with Braathens Wings, of course.

8 enkle spørsmål **vinn tur til Milano**

>> Text ("8 simple questions. Win a free trip to Milan…") replaces graphics in this banner, but the message still appeals to Scandinavians' wanderlust.

Copy.Eystein Ruud / **Art Director.**Christian Bjoerndalen / **Web Designer.**Frank Undeheim / **Account Manager.**Anne Mikkelsen
Tools Used.Adobe Photoshop / Adobe Illustrator / Dreamweaver / Cold Fusion / Macromedia Flash / Macromedia Director

Marketing Objective:

Inform customers about the advantages of the new Wings frequent flyer program for Braathens, the Norwegian airline, while obtaining information about potential customers.

Creative Strategy:

While a print campaign informs current customers about the changes from the old BraCard program to bonus miles from Wings, the online campaign successfully gathers information from new prospects.

Media Placement:

Banner ads placed on sites often read by frequent flyers have the sole mission of driving consumers to the campaign site.

Vinn tur for to til Milano!

BRAATHENS
WINGS
Den korteste veien til de lengste bonusreisene

Ingen spørsmål

New York

BRAATHENS
WINGS

>> Through its appealing and clear offer, Leo Burnett Interaktiv entices users to a jump page featuring the Wings frequent flyer program.

>> Users learn about the Wings program while Braathens learns about them through a series of simple questions.

>> The answers gleaned tell Braathens such details as how many times each traveler flies each year and on what airlines, enabling them to make a better Wings offer.

>> The home page for NetCom MotHer Magazine, a lifestyle e-zine.

>> The banners pose everyday problems like how to know when your mother-in-law is calling or how to keep your home in order.

>> The answers are forthcoming on the other side of a click.

Copy.Eystein Ruud / **Art Director.**Christian Bjoerndalen / **Web Designer.**Roger Stemsrudhagen / **Account Managers.**Anne Mikkelsen, Erik Kristiansen
Tools Used.Adobe Photoshop / Adobe Illustrator / Dreamweaver / Cold Fusion / Macromedia Flash / Macromedia Director

Marketing Objective:

Get people to register for MotHer, an integrated Internet and cell phone service that also provides an online calendar, message service, lifestyle magazine, and other information services.

Creative Strategy:

The design reflects an image of mamas like they used to be in the "good old days."

Media Placement:

Sites reaching the target audience of young people between 15 - 25, as well as direct mail, cinema commercials, and public relations.

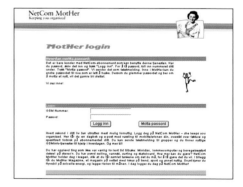

>> A microsite designed for each of the banners tells you how NetCom, a cell phone company, can help you solve the problem and get organized by using a digital "mother." It also invites you to register for the service.

>> Responding to the hip design and humorous content, new customers signed up at the rate of one per minute.

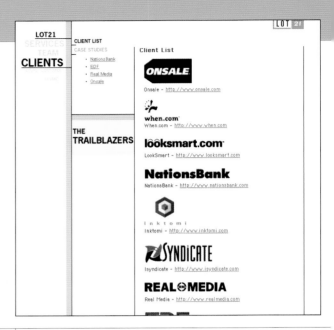

>> Lot21 uses simple, clean elements so visitors are able to intuitively navigate its site.

>> Its client list prominently displays logos, as well as links to case studies that document some of the company's brand-strategy and product-awareness successes.

>> When the Postal Service laughs at itself, people listen.

>> A seamless transition to the Web for a familiar mainstream advertiser.

>> Winner of a gold @d-tech award for audience building campaigns.

Lot21 Interactive Advertising

Lot21, launched in February 1998 by Kate Everett-Thorp, is an interactive marketing, media and advertising agency specializing in integrated marketing solutions for advertisers. It is one of the few pure-play interactive agencies, focusing solely on online advertising and the integration of the medium beyond the banner.

"Although standards and tools need to continue to mature, we feel strongly that those who only hang on to the traditional view of advertising are missing the boat," says Lot21 president and CEO Everett-Thorp. "At the speed with which the Internet is evolving, they might as well get off."

More than any other advertising medium, the Web must make information accessible. Lot 21 attributes its success to understanding what attracts viewers to an online ad, what drives them to pursue the message, and how these trends can shift rapidly. It embraces the use of new technologies to develop solutions, such as its @d:tech award-winning at Cost Flash Generator Banner for Onsale, that meet the diverse needs of interactive advertisers. "To advertise effectively," says creative director Paco Viñoly, "you need to speak directly to the audience within a flexible and innovative framework." The Lot21 team has been producing technologically innovative advertising since the early days of the Web, from banners on Wired to Java, Shockwave, interstitials, and microsites.

Viñoly's creative specialists produce compelling advertising that capitalizes on media placements. "Extensive research and branding initiatives are crucial to the development of any successful online advertising effort," says Viñoly. As a result, Lot21's ads not only reach out to the appropriate audience, but also demonstrate effective design strategy that represents its clients' brand and advertising messages.

Inventing — and Reinventing — for the Web

> *To convert prospects to customers, eliminate the obstacles between people and your product or service.*

> *We're always inventing the future of advertising.*

> *When we get dogs to buy their dog food online, we'll know we have this industry perfected.*

>> Seagate banners lead to a microsite that offers everything from news to shopping.

Address.548 Fourth Street, San Francisco CA 94103 / **Voice.**415 227 2121 / **Fax.**415 227 2121 / **E-mail.**mollyp@lot21.com /
Web Site.www.lot21.com / **Executives.**Kate Everett-Thorp.President & CEO, Paco Viñoly.Creative Director

>> Onsale

>> This online commercial, which ran glitch-free on ZDTV's "Money Machine" for three months, may be viewed at www.lot21.com/public/ex/ons_zdtv/ in a variety of QuickTime and RealVideo formats.

>> Enliven banners using Macromedia Flash banners allow Lot21 to brand while offering extended interaction.

>> Every 15 minutes, a PERL script fetches live auction information pre-selected by Onsale.

>> The ad captures the excitement of online auctions.

"hey…"

"…over here"

The best deals on brand name computers are just one click away!

>> Rich media is a perfect fit for Onsale's fast-changing bidding wars.

Creative Director.Paco Viñoly / **Director of Technical Design.**Sasha Pave
Tools Used.Adobe Photoshop / Macromedia Flash / Macromedia Flash Generator / Macromedia Fireworks / Adobe Illustrator

Marketing Objective:

Increase overall traffic flow and sales for Onsale, a leading online live-auction retailer, and bring down the cost per acquisition through informative advertising aided by rich media technologies.

Creative Strategy:

With its ZDTV spots, Lot21 created rich media ads for the first time for Onsale, running Macromedia Flash, Enliven, and Flash Generator banners with a message and a purpose creating an urgency: "Buy This Now." The ability to deliver real-time or personalized information in a compelling, interactive format with minimal custom programming allows Lot21 to extend brand while offering greater interaction. With Onsale's fast-changing bidding wars, rich media is a perfect fit.

Media Placement:

Sites that accept mainstream rich media advertising formats, such as the Onsale Generator and Enliven banners, with the appropriate demographic and psychographic information.

 >> >>

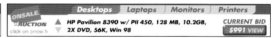

NationsBank

I want a credit card that fits my lifestyle?

Signature loans
for what you want

I want a credit card that fits my lifest

Signature loans
when you want

I want a credit card that fits ?

Signature loans
wherever you're posted

I want a credit card that fits my budge

as low as
10.99%
APR

I want a credit card that fits both.

Apply now.

I want a credit card that fits *both?*

we've got a credit card to suit your needs.

Apply now.
CLICK HERE

CLICK HERE FOR THE
ONLINE CARD FINDER! **NationsBank**

>> Flash technology communicates how NationsBank broadens your lifestyle.

>> Qualified (approved) applications tripled within the first week of the media campaign.

 NationsBank

 2ᴾᴹ, Maui **NationsBank**

 2ᴾᴹ, Maui
Check Your Balance, Transfer Funds **NationsBank**

>> NationsBank banners were placed in shopping areas to reach users who are comfortable making a transaction online.

The New Color of Money. APPLY ONLINE NOW! CLICK HERE. **NationsBank**

The New Color of Money. APPLY ONLINE NOW! CLICK HERE. **NationsBank**

The New Color of Money. APPLY ONLINE NOW! CLICK HERE. **NationsBank**

>> This banner promotes low introductory rates for the Platinum card to attract cardholders looking to expand their financial leverage.

Creative Director.Paco Viñoly / **Director of Technical Design.**Sasha Pave
Tools Used.Adobe Photoshop / Macromedia Flash / Macromedia FlashGenerator / Macromedia Fireworks / Adobe Illustrator

Marketing Objective:

Reach the households of NationsBank's affluent target market and encourage them to use NationsBank Online Financial Services.

Creative Strategy:

Achieve consistent and prominent branding, and convey a tone of strength and power in sound money management, through the use of captivating Flash technology or sharp graphics.

Media Placement:

Geographic targeting of city guides, finance, and shopping sites to establish visibility in areas where NationsBank is highly recognized by consumers.

>>

>> Clean, crisp visuals cut through the noise for financial service offerings on the Web.

>>

NationsBank Online
NationsBank

NationsBank Online
Anytime, Anywhere.
NationsBank

NationsBank Online
Click here to begin using Today!
NationsBank

The New Color of Money.
APPLY ONLINE NOW! CLICK HERE.
NationsBank

Visa Platinum.
Great Low 5.9% Intro APR
APPLY ONLINE NOW! CLICK HERE.
NationsBank

Visa Platinum.
Great Low 5.9% Intro APR
APPLY ONLINE NOW! CLICK HERE.
NationsBank

15 16 17 18 19 **20** 21 22 23 24 25 26 27 28

 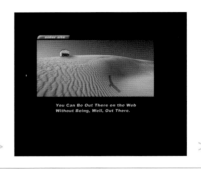

>> M2K's Web site opens with an interstitial created in Flash. Its clever animations tell the story of the agency's offerings to clients.

The Idea Is To Sell Something

> *The best Web advertising design is created with an understanding of the contexts —*
the different types of Web sites — in which it will be used.

> *With business-to-business advertising, it is important that design does not compete*
with or, worse, obscure the copy message.

> *Simplicity is always good. Design fast; communicate faster.*

M2K

M2K began delivering advertising and direct marketing services to high-tech companies in 1988. Its focus from the outset has been to deliver measurable results by providing marketing services that support the entire brand-to-sale process. Today, much of its emphasis is on the Internet. It develops sophisticated Web and e-commerce sites in partnership with a Web systems integrator, and it drives traffic to these sites using a combination of online and offline advertising and direct marketing.

M2K believes that it should, first and foremost, honor the time and intelligence of the audience. "We are not great fans of 'noisy design' or executions that ask far too much of the marketplace," says creative director Chris Maher. He points out that even though Web advertising is relatively new, it is already exhibiting a maturing process.

"Despite what some may have believed, the mission isn't to impress a client—or our colleagues—with our use of this or that particular technology. We aren't resellers doing demos. We're in the business of communicating and connecting with customers." If that means that a certain new technology is necessary or appropriate, M2K will certainly use it. "With zeal," Maher adds.

M2K was among the first interactive agencies to use text link banners and blinking link (or "blinks") banners. That came from some research M2K saw that indicated Web surfers associate banners with ads (low credibility) and links with substantive information (high credibility.) "It made sense to use these kinds of banners for business-to-business buyers who tend to be information-focused," explains associate creative director Eric Sutherland. "We actually got into a little trouble with a few Web sites because our links were deliberately meant to mimic the appearance of their site's text links."

Maher says that it is difficult to avoid the clichés about the differences between Web and offline design. The Web world is all about two-way communications, dialogues, instant gratification, speed, motion, and "intense time," he points out. There also is a certain informality and irreverence associated with it. We're also on the brink of achieving mass-customized Web advertising messages on a scale that has not been possible before. "It's an exciting time," Maher says. "Especially for an agency whose roots are deep in direct marketing."

>> A bee from the last frame of the M2K interstitial leads the viewer to the home page, with its clean, graphical navigation scheme.

>> Smartpromo.com, an example of a full e-commerce solution from brand to sale, embodies M2K's trademarked "Storefront to the Forefront" concept by bringing the sales floor directly to the opening page of the site.

Address.313 South Congress, Suite 200, Austin TX 78704 / **Voice.**512 448 7791 / **Fax.** 512 448 7769 / **E-mail.**rmcewen@m2k.com /
Web Site.www.m2k.com / **Executives.**Rob McEwen.CEO, Chris Maher.Agent Provocateur

Compaq Deskpro EP Series PC Customers:
Follow This Link to NIC Savings.

>> A "link banner" that looks like a featured story on a news Web site
is very effective in eliciting click-through.

People Finder · Shareware · Company Profiles · More...

| THE RIGHT NIC FOR COMPAQ DESKPRO EP SERIES PCs | GO! |

COMPAQ Use Extra Search Precision within [Web Sites ▾] ◂┄┄

>> This banner is disguised as a search box.

COMPAQ

To Order,
Call Now!
1-800-544-5255

**GET A FREE
T-SHIRT**

COMPAQ

Ready to save $10 off
each Compaq Fast
Ethernet Wake on LAN
NIC with your next
Deskpro EP Series
purchase? Call your
friendly reseller or
1-800-544-5255.

Compaq Deskpro EP Series PCs &
Compaq Fast Ethernet NICs:
Get the Most from Compaq Intelligent Manageability

Built on Intel Fast Ethernet Silicon.

- Get **Intelligent Manageability** features working
 for you with our LAN-savvy Deskpro EP Series
 desktops and NICs.
- Save $10 on each Compaq 10/100 Wake on
 LAN NIC with your next purchase of
 award-winning Deskpro EP Series PCs.

Here's the deal. Order your powerful Compaq Deskpro
EP Series desktops with Compaq 10/100 Wake on LAN
NICs, and you'll save $10 on each NIC. (Let's do the
math: That's $10,000 of NIC savings with the purchase
of 1,000 Deskpro EP Series PCs.)

These aren't just any NICs. Because they're part of
Compaq's **Intelligent Manageability** solution, you get a
high-performance, safe solution with one-stop support.
And don't forget the added sweetness of being able to
use either Compaq or Intel drivers.

Intelligent Manageability: What's in It
for You?

Our 10/100 Wake on LAN NIC offers these additional **Intelligent Manageability** features when
installed in a Compaq Deskpro EP Series PC:

- Network service boot for simplified setup of a new system.
- DMI 2.0 compliance for inventory control and remote system diagnostics.
- Wake on LAN technology for remote after-hours maintenance.
- And ACPI (Advanced Configuration and Power Management Interface) for reduced power
 consumption.

And the powerful Compaq Deskpro EP Series is designed to take full advantage of these capabilities.
Fact is, the combination of Compaq Deskpro EP Series PCs and Compaq 10/100 Wake on LAN NICs,
rounding out your **Intelligent Manageability** solution, just makes sense. And with $10 off each NIC,
it's a lot easier to grasp the logic. But hurry, this deal is going away as of December 31, 1998.

>> A jump page explains benefits and offers a deal.

CEO.Rob McEwen / **Creative Director.**Chris Maher / **Art Director.**Eric Sutherland / **Design.**David McKnight / **Programmer.**Tom Kiehne / **Production Design.**Jana Jacob
Tools Used.Macromedia Fireworks / Macromedia Flash / Adobe Illustrator / Adobe Photoshop / Macromedia Director

Marketing Objective:

Get Fortune 1000 Compaq DeskPro customers to order Compaq Intel-based NICs pre-installed not only because they are an obvious choice, but also because they're the *best* choice.

Creative Strategy:

An online campaign targets IT professionals who buy networking equipment; a jump page offers additional information about the product and generates leads for the sales team; a direct mail piece is sent to 50,000 IT professionals.

Media Placement:

The banner campaign ran on sites like Network Magazine, Network World Fusion, Plug-In Datamation, and InfoWorld, yielding an overall 7 percent click-through rate.

GET
Intelligent Manageability
Features Working For You
WITH
Compaq Deskpro EP Series PCs
AND
Compaq Fast Ethernet NICs.

>> This banner is designed to complement the mailer.

Save $10 off each Compaq 10/100 Wake On LAN NIC—built on Intel Fast Ethernet silicon—with your Deskpro EP Series PC purchases. That's not just intelligent. That's brilliant.

COMPAQ

>> M2K, whose roots are in direct marketing, strongly believes in integrating online and offline marketing to drive traffic to Web sites. This mailer yielded a higher-than-expected 4 percent response rate.

>> i2 Technologies' eDay

i2 Technologies
the new Rhythm of business

>> To establish a stronger brand, M2K's advertising has a consistent look and feel both online and in print.

EXPRESS LANE
1,500 ITEMS
OR LESS

Accelerate Your Brand

Not many people know about our flexible, quick-to-implement supply chain management solutions for consumer goods and retail. But those who do are in excellent company, like Frito-Lay, Russell Athletic, Mars, Ernest & Julio Gallo, Andrew Jergens, Nordstrom, Sears, Whirlpool, and The Sherwin-Williams Company.

www.i2.com

>> The theme of the eDay event is "InternetTime" moving faster and faster. This ad ran in *The Wall Street Journal*.

CEO.Rob McEwen / **Creative Director.**Chris Maher / **Art Director.**Eric Sutherland / **Design.**David McKnight / **Programmer.**Tom Kiehne / **Production Design.**Jana Jacob
Tools Used.Macromedia Fireworks / Macromedia Flash / Adobe Illustrator / Adobe Photoshop / Macromedia Director

Marketing Objective:
To brand i2 Technologies' eDay concept—"the day that eBusiness finally comes of age"—with an integrated campaign.

Creative Strategy:
Mindful of campaign consistency, all the executions reflect the time/speed/clocks and stopwatches themes, and the online registration page most critically reflects the creative content created for other media.

Media Placement:
Combination of online, print, and direct mail.

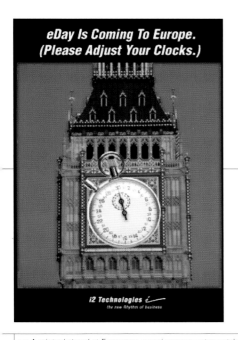

>> A print ad aimed at Europeans superimposes a stopwatch on a familiar icon of time.

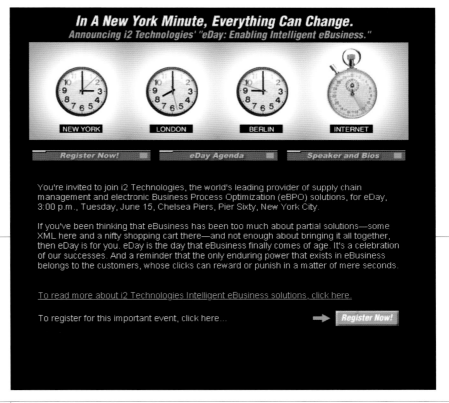

>> The clock hands on this registration page, which recall the print ad for *The Wall Street Journal*, are animated.

>> A splash page for Manne & Co. sets the tone for the company's philosophy of giving brands a strong personality.

>> The agency's sparse and uncluttered home page.

Putting Personal Touch
Before Technology

> *Good-looking people attract attention; the same goes for advertising.*

> *Too much Web advertising lacks personality.*

> *Test your creative. If people don't go "wow," start all over again.*

>> This campaign is for Svensk Adressndring (The Change of Address Company), which takes care of Swedes when they are on the move.

>> Manne & Co has created TV ads for Svensk Adressndring for many years, urging people to report changes of address with a phone call..

Copywriter.Martin Stadhammar / **Art Director.**Christer Coos / **Account Manager.**Albin Gustafsson / **Support.**Oskar BŒrd / **Music.**Tor Bergman / **Web Production.**Speedway Digital Army:
David Sundin, Fredrik Karlsson and PeterStrom / **Project Manager.**David Sundin / **Programming.**David Sundin

Manne & Co.

Manne & Co., one of Sweden's hottest agencies, approaches the Internet from a traditional advertising and integrated-communications background. Founded in 1995, it's a full-service agency for a wide range of clients, including major insurance companies, television channels, home-entertainment companies, and business magazines. It focuses on creativity and original ideas. "We always generate 20 to 30 ideas for every job," says CEO Manne Schagerström. "That leaves us with at least one strong idea to which we can give life on the Web." Schagerström also believes in strict controls to measure results. "Know where you are going," he says, "and why you are going there."

Manne & Co. treats the Web the same as any other media and integrates its executions across various outlets as part of the creative process. "Web advertising seldom reaches its ideal standing alone," says Schagerström. "It gets strength from visibility in other places. We create concepts that bridge the different media." The agency relishes the challenges presented by the ever-changing nature of the Web. It is also undaunted by technological limitations. "Strong ideas are more vital for success than technology. While many others complain," Schagerström says, "the limits give us energy. 468 x 60 is more than enough space to be funky."

Creativity and good design can lower the degree of what Schagerström calls "banner blindness." It's also important to keep creative fresh, he says, to avoid boring the audience with over-exposure. The agency works closely with the leading commercial Web sites to try new ideas. Schagerström says that, thanks to frank dialogue, the new ideas are greeted enthusiastically. "We have pushed things all the way," he says. "The ultimate goal is to arrive at win-win situations, showing new directions for Web advertising."

>> A song created for one of the commercials, "Moving out is a wonderful thing," was such a hit that it was released on CD and made the charts.

>> In what is probably the first-ever karaokebanner, the ball bounces and music starts playing when the pointer is moved to the banner.

>> Using DoubleClick's targeting capabilities, the banner was delivered only to Swedish university students on 15 different American Web sites.

Affiliated with the A-Com Group / **Address.**Kungsgatan 48 111 35, Stockholm Sweden / **Voice.**+ 46 8 20 60 31 / **Fax.**+ 46 8 21 03 25
E-mail.direct@manneco.se / **Web Site.**www.manne.nu / **Executives.**Manne Schagerström.CEO

>>

>> There's nothing out-of-the-ordinary about the banner at the top of the page. But at the bottom, where you'd expect to see more of the same, a fire rages.

>> Holy smokes! The fire is creating fumes..

>> The smoke moves up the right side of the page.

>> It obliterates the banner.

Copywriter.Martin Stadhammar / **Art Director.**Sten Okerblom / **Account Manager.**Albin Gustafsson / **Supporter.**Oskar Bård / **Illustrator.**Magnus Carlsson / **Web Production.**Tesch & Tesch / **Web Designer.**David Sundin / **Account Manager.**Robert Mellberg

Marketing Objective:

Position Wasa Insurance Co.—a Swedish insurer situated midmarket between insurance giants with strong profiles and small companies focused on niches—as the specialist for insuring companies.

Creative Strategy:

Most ads for financial services, on the Internet and in other media, look alike (dimmed pictures of happy families, and so on) and have lost their power. Manne & Co.'s bold cartoon-like approach, which builds on a concept developed for TV and print, breaks the mold for Web advertising in several ways. Fresh daily executions also help to prevent banner blindness.

Media Placement:

Banners based on TV commercials ran on the site for DagensIndustri, the major business paper in Sweden.

>>

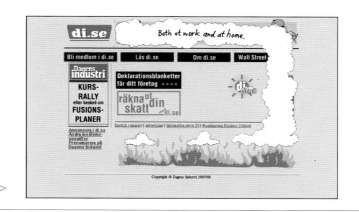

>> And ends with the company logo and a concise message.

>> Readers perusing the day's news suddenly see something emerge on the left side of the screen.

>> An airplane flies right across the page.

Copywriter.Martin Stadhammar / **Art Director.**Oskar Bård / **Account Managers.**Albin Gustafsson, Susanne Fuglsang / **Production Supervisor.**Åsa Marklund / **Illustrator.**Ricky Tillblad / **Web Production.**Speedway Digital Army: David Sundin, Fredrik Karlsson and Peter Ström

Marketing Objective:

Get attention for, and generate traffic to, the relaunch of the Telia InfoMedia GulaSidorna (Yellow Pages), the leading Swedish site for finding business phone numbers.

Creative Strategy:

To add a personal touch to a service that could be perceived as somewhat boring, Manne & Co. used DHTML that showed traditional, if offbeat, advertising media—a blimp, an advertising car, and a banner-trailing airplane—skimming across the Web space.

Media Placement:

The vehicles flew, drove, and moved across the screen of Aftonbladet.se, the major Swedish evening newspaper on the Internet.

>> It carries a message, as do airplanes flying over cities, beaches, and stadiums.

>> The banner disappears into the right-screen horizon.

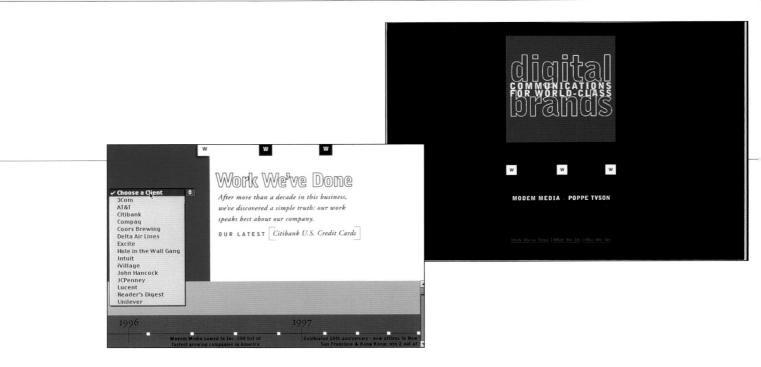

Relationship-Building Through Functional Design

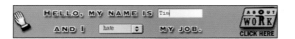

>> These banners for About Work satisfy the customer's need on the spot.

>> Demonstration of Citibank's ability to deliver critical information in the banner itself.

23
Modem Media . Poppe Tyson

A little over a decade ago, Modem Media became the first agency to dedicate itself exclusively to interactive marketing. It has won more awards for interactive work than any other agency. Poppe Tyson, founded in 1924 even as the first radio ads were airing, also adopted interactivity early. The 1998 merger of these two interactive pioneers created a global powerhouse in digital marketing communications, with 400 employees in New York, San Francisco, Chicago, London, Hong Kong, Toronto, and Westport, Connecticut, plus an affiliate office in Sao Paolo, Brazil.

Modem Media . Poppe Tyson believes that an ad is a nuisance until a consumer needs it. Then it becomes a service. "This requires that we target our advertising to intersect with people whose behavior demonstrates a real need to interact with our client's brand," says Joe McCambley, worldwide executive creative director .

All of Modem Media . Poppe Tyson's work is designed to be sleek, uncluttered, and attention getting—but most of all, utilitarian. It aims to satisfy customer needs on the spot. In doing so, it collects enough information to accurately estimate a consumer's potential value to its client's brand, then uses various customer-management techniques to create a relationship.

"Interactive provides something you can't buy in any other medium, and that's the ability to interact with, and around, the brand," says Tom Beeby, Creative Director. "You can demonstrate for yourself the relevance of that brand in your life." Because of bandwidth constrictions, however, file sizes must be kept to a minimum. There is no comparison to the resolution of a photograph in a print ad and the same image on the Web. "Consumers seem more than willing to give up resolution in exchange for control, relevance, and utility," says Beeby. "That doesn't mean that design isn't important. It is. We strive for elegant functionality."

Modem Media . Poppe Tyson's campaigns for AT&T and John Hancock on the following pages show how an ad can convert a prospect into a customer on the spot through simple, engaging copy and graphics. It has also created Internet marketing solutions for global brands such as Citibank, Delta Air Lines, E*Trade, IBM, JC Penney, Sony Computer Entertainment of America, and Unilever.

> *Allow meaningful interaction with the brand at the "banner" level.*

> *Don't wait for the consumer to come to your site. Bring utility to the consumer.*

> *Intersect, capture data, and build the relationship.*

Address.230 East Avenue, Norwalk, CT 06855 / **Voice.**203 299 7000 / **Fax.**203 299 7461 / **E-mail.**rallen@modempoppe.com /
Web Site.www.modempoppe.com / **Executives.**Tom Beeby.Creative Director, G.M.O'Connell.Chairman & CEO, Bob Allen.President & COO,
Joe McCambley.Worldwide Executive Creative Director

AT&T Digital One Rate

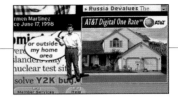

>> The character in the ad begins by speaking to us from his wireless service "home" coverage area.

>> He steps out of his wireless services home coverage area (and out of the ad) to command attention and make his point.

Creative Director. Tom Beeby / **Associate Creative Director.** Peter Rivera / **Senior Art Director.** Lillian Rousseau / **Art Director.** Lisa Parett / **Graphic Designer.** John Damato / **Copywriter.** Kitti Borgati

Marketing Objective:

Drive sign-ups for AT&T's Digital One Rate Wireless Service.

Creative Strategy:

Communicate that AT&T Digital One Rate Service has no long distance or roaming charges when you leave your home coverage area, no matter where you go in the U.S.

Media Placement:

Because the ad ran on the @Home Network, a broadband cable service, Modem Media . Poppe Tyson could create a higher file size using non-mainstream technologies such as Shockwave, JavaScript and DHTML. The result is a Web ad that literally goes "out of the box" to drive home the key selling point.

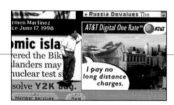

>> He drives home the key selling point: no long distance or roaming charges outside of the home coverage area.

>> The character introduces the call to action, asking us to click the ad and launch a browselet to demo the phone.

>> We launch the browselet, which is complete with fully functional, audio-enabled phone demo, interactive coverage map, FAQs, purchase information, and more. We've still not left the page on which the ad is running. Instead, the ad brings the utility to us.

Tools Used. Shockwave / JavaScript / DHTML

15 16 17 18 19 20 21 22 **23** 24 25 26 27 28

John Hancock

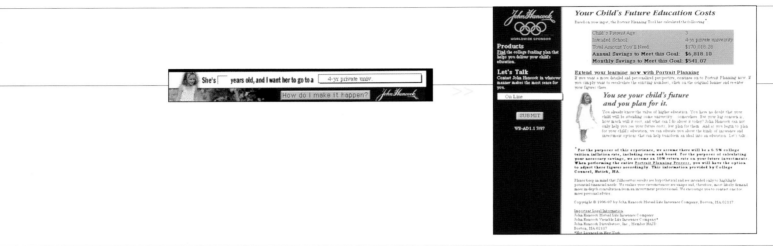

>> Each of the banner executions approaches a different real-life financial concern with the promise of real-time answers.

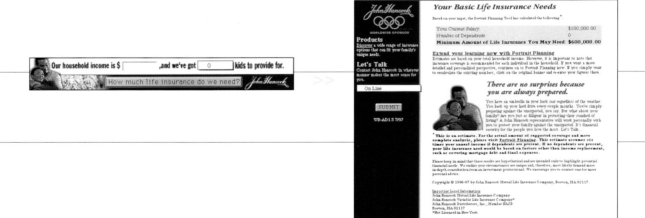

>> The resulting pop-up browselet provides us with meaningful information on how to meet our real life financial goals, with an invitation to learn more, or to speak to a representative by visiting the John Hancock site.

Marketing Objective:

Drive registrations for the John Hancock Portrait Planning tool, a tool that helps users with financial planning and insurance needs.

Creative Strategy:

The four JavaScript-powered Silhouette banners draw us in with the promise of instant, personalized responses to questions relating to college, savings, retirement, and insurance needs. This requires a clean, telegraphic, "hey, that's my life!" approach to the design and copy.

Media Placement:

This condensed version of the Portrait Planning tool, normally only available to users from the John Hancock site itself, enables consumers all over the Web to obtain immediate "real life" answers to key financial questions without leaving the sites they are visiting.

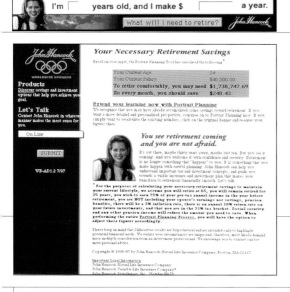

>> Modem Media . Poppe Tyson designers felt that to be effective, they could only use two fields to gather data. They worked with John Hancock to limit the required data-entry points accordingly.

>> These banners epitomize Modem Media . Poppe Tyson's philosophy of meaningful interaction at the ad level.

Creative Director.Lino Ribolla / **Art Director**.Steven Cloud / **Senior Copywriter**.Charles Marelli / **Copywriter**.Mark Goulding

e-business consultants **mvlg**
mathura • verhart • van der linden • gerrits

about us | what we do | contact

nobody's perfect...
...but a team can be

the digital marketplace

The online and real-time capabilities of interactive media such as the Internet have given birth to a new business environment played by different rules. It is not merely another marketing channel; it's a different way of doing business. To benefit from these new interactive opportunities, organizations often have to change their strategy, marketing, processes, structure and culture.

MVLG is totally focused on e-business. We believe it represents the future way consumers and businesses will interact and transact business. We can change the way your business operates!

breaking news

wanted: e-business consultants!
As a consultant for MVLG you will participate in the analysis, design and development of e-business solutions. You will participate in our projects using the MVLG toolbox of methods and techniques to realize cutting edge e-business projects. **<more>**

May 18, 1999

>> MVLG e-business consultants home page.

e-business consultants **mvlg**

making your
business work with E!

what we do

business consulting
interactive marketing -
e-Process Redesign -
e-Organization & Change -
project & interim management

e-business consultants

E-business refers to re-inventing your business models and processes with a view to conducting all aspects of your business through electronic and interactive channels.

MVLG can advise your organization on how to use interactive channels for establishing a virtual business, reducing costs in managing supplier-distributor relationships, delivering services electronically and exporting/selling into new markets. MVLG can help you prepare a business case, assess the business viability of an idea or project, become familiar with opportunities and threats to your business, understand the involved technologies and solve business-critical problems for implementing e-business solutions.

Our key focus areas are (e)business consulting, project & interim management as well as research & competitive analysis.

copyright mvlg 1999

>> MVLG states its case for re-inventing business models.

Bringing Brands to Life

> *Define the big picture behind the campaign and work like hell to vary from the industry norm.*

> *Interactive media brings your brand to life.*

> *Advertising is about giving more attention to your target group than your competitor does.*

MVLG e-Business Consultants

Ashu Matura, Bas Verhart, and Mark van der Linden founded MVLG e-business Consultants in May, 1997, and were joined the following year by Han Gerrits. MVLG works with professionals from a variety of backgrounds and disciplines to create integrated brand communication strategies that go beyond advertising to include marketing, process re-engineering, and organizational change via interactive media. "Nobody is perfect, but a team can be," Verhart says. MVLG has clients in such diverse categories as finance, tourism, entertainment, government, IT, services, and consumer goods.

"When consulting on Web advertising, we try to integrate the traditional campaign with the Internet campaign," says Verhart. "By doing so, our clients can take full advantage of the synergy between different media."

MVLG's Web advertising philosophy is to "define the big picture behind the campaign and work like hell to vary from the industry norm," Verhart says. "Traditional advertising lacks the ability to create a true brand experience. We believe that the Internet provides an unique opportunity to tell the story, concept, or philosophy of the company behind the brand," he continues.

Marketers can use TV commercials, for example, to drive customers to their Web sites, where it becomes imperative to communicate effectively with customers and foster a high degree of involvement. MVLG believes that successful interactive marketing campaigns depend on building relationships and loyalty.

"Together with our clients we strive to give each campaign a competitive edge," Verhart says. After determining what the client wants to achieve, MVLG runs through a series of steps to maximize return on investment. Those steps include campaign strategy, segmentation, a creative checklist, a media-planning checklist, briefing media buyers, pre-launch testing, performance monitoring, and evaluation.

"Every step in the process has to fit the total concept behind the brand," according to Verhart. "And every interactive concept must breathe life into the brand."

>> A teaser advertisement for the agency.

>> The answer to the teaser ad.

Affiliated with Winkelman & Van Hessen / **Address.**De Lairessestraat 156, 1075 HL Amsterdam The Netherlands / **Voice.**+31 (0)20 570 35 35 / **Fax.**+31 (0)20 671 72 49 / **E-mail.**ebusiness@mvlg.com / **Web Site.**ebusiness@mvlg.com / **Executives.**Ashu Mathura.Managing Consultant, Bas Verhart.Managing Consultant, Mark van der Linden.Managing Consultant, Han Gerrits.Managing Consultant

The Netherlands Board of Tourism

>> If Vincent van Gogh isn't enough to catch your attention, "click & win" surely is.

>> Keyword targeting on Travelocity.

>> After users click — and more than 2.5 percent do — they receive a pop-up providing options to visit the official Holland portal, the official Amsterdam portal, or to enter a sweepstake.

Art Director. Thomas Magermans (OASE/Netlinq)

Marketing Objective:
Increase traffic to several official Web sites of The Netherlands Board of Tourism, which promote The Netherlands as an interesting vacation destination.

Creative Strategy:
People searching for information about Holland, The Netherlands, or Amsterdam on Travelocity see a banner with Dutch painter Vincent van Gogh explaining where to find details about the country and its capital. People searching for other European destinations see banners that position Amsterdam as an interesting alternative.

Media Placement:
Branding campaign aimed at active travelers on Travelocity; keyword targeting on Altavista.

>> The pop-up offers users two Web sites.

>> Logo for the Design Contest 98.

>> The "Interact" page for the design contest where the number of participants can be found, together with some interesting links and the e-mail address.

Art Director.Brian Barr

Marketing Objective:
MVLG developed Design Contest 98 'Who Can?' for Heineken to generate new product and packaging ideas for the brewery and learn about what moves the Net Generation, while positioning it as an innovative company.

Creative Strategy:
The Web site contains extensive information on the contest, as well as the opportunity to interact with the contest organizers or with other contestants. The funky design and typography is directed at attracting designers and product developers.

Media Placement:
Because of a limited budget, all efforts centered on generating free publicity through a press release that was sent to 132 international Web sites related to the theme of the contest.

>> The 'pass it on' button proved to be a very effective way to attract visitors and make them advocates of the site.

>> And the winner is . . .

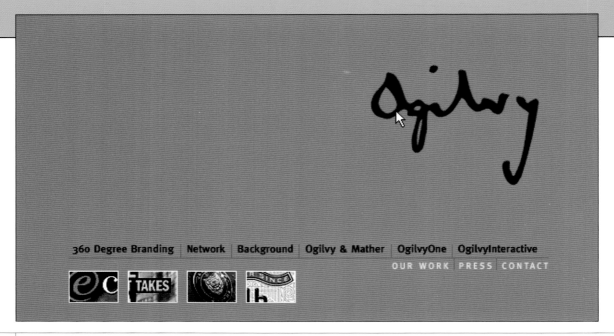

360 Degree Branding | Network | Background | Ogilvy & Mather | OgilvyOne | OgilvyInteractive

OUR WORK | PRESS | CONTACT

>> The Ogilvy brand needs little introduction to Fortune 500 marketers.

Rich Media: In the Banner and Beyond

> *Focus on how the brand is to be represented within the context of the online model.*

> *Interactive design as a discipline may be more closely related to industrial design than it is to graphic design.*

> *Applying a consistent brand strategy at every point of contact is the backbone of building brand loyalty.*

 >>

>> An enticing banner for Jaguar Select Edition "pre-owned" vehicles opens to a informative four-panel pop-up.

>> A Lotus banner takes an empowerment theme to superhuman levels on its jump page.

OgilvyInteractive Worldwide

In his tour de force *Confessions of an Advertising Man*, Ogilvy and Mather founder David Ogilvy writes, "It is the professional duty of the advertising agent to conceal his artifice. When Aeschines spoke, they said, 'How well he speaks.' But when Demosthenes spoke, they said, 'Let us march against Philip.' I'm for Demosthenes."

Although Ogilvy is referring to advertising and graphic design for what we now call "traditional" media—print, broadcast, and outdoor—his insight rings as true today as it did 36 years ago. "A good advertisement," Ogilvy writes, "is one which sells the product without drawing attention to itself." Likewise, good interactive design inspires its audience to act, or interact, in a manner that is both fluid and intuitive—without drawing attention to itself. To design such an interface, in fact, is the essence of new media artistry, according to Jan Leth, executive creative director at OgilvyInteractive.

"In the best interactive design, aesthetics and experience combine to leave an impression more lasting than either could make alone," says Leth. "This impression is what we call brand identity. Brand identity is the result of a relationship between our client and the consumer at all points of contact—across borders, divisions, and disciplines—and is the core of our agency philosophy."

OgilvyInteractive's first step toward building a brand identity is to immerse itself in its client's products, services, and culture until it understands them thoroughly. It then focuses on how the brand is to be represented within the context of the online model. Whether it is guiding the user through an experience, asking for a transaction, or exchanging information, the impression must have consistent brand identity across all media—including direct marketing, corporate communications, packaging, signage, and even business cards. "Applying a consistent brand strategy at every point of contact is the backbone of building brand loyalty," Leth says.

Because the nature of the Web—whether it is being used for communication or transactions—is that of one-on-one communication, interactive designers must work to cultivate engaging dialogue, according to Leth. Writers, art directors, and information architects should understand the art of conversation and know how to engage others in dialogue. Since even the most skilled designer cannot make poor content engaging, there needs to be a captivating story.

Interactive design as a discipline may be more closely related to industrial design than it is to graphic design, according to Leth. A multimedia interface may be a dynamic, multidimensional tapestry of graphics, text, video, and sound that is a really a tool or application rather than a piece of art.

"Many traditional designers consider the unpredictable nature of interactive design to be a limitation," Leth says. "Our designers see it as opportunity. The ability to offer the user a unique experience opens doors that never existed in traditional media. Moreover, the convergence of technology and commerce is creating new possibilities for designers to enhance the user experience and to create a even more lasting impression—or brand identity."

OgilvyInteractive's revenues nearly quadrupled in one year to $60 million in 1998, and the staff grew from 40 to more than 175 specialists in interactivity. In addition, the agency was named one of *Adweek's* Top 10 interactive ad agencies. It has received numerous awards including two Cyber Lions Award, two CASIE Awards, and the first-ever Grand ClioInteractive for its work with IBM Internet Technology.

>>

An integrated offering of OlgilvyOne Worldwide / **Address.**309 West 49th Street, New York NY 10019 / **Voice.**212 237 6000 / **Fax.**212 237 5123 / **E-mail.**mary.fichter@ogilvy.com / **Web Site.** www.ogilvyone.com / **Executive.**Carla Hendra.President OgilvyOne, New York Chief Creative, Jan Leth.Executive Creative Director OgilvyInteractive, New York

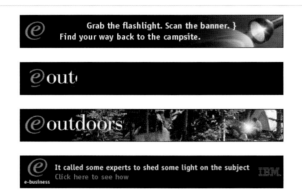

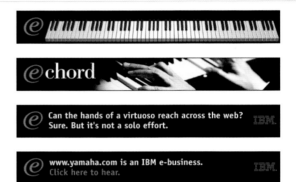

>> The interactive banners work by offering a bit of fun and intrigue before the serious sell. For REI, a retailer of outdoor gear, the banner becomes a forest at night and users operate a "flashlight" to find their campsite.

>> Because there's no way to fully explain each IBM-customer relationship in a banner space, Ogilvy created a set of visual metaphors. For Yamaha, the banner becomes a playable piano.

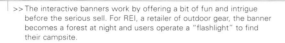

>> For Vespa, it's an Italian village to motor through (with love as the reward).

Marketing Objective:

To communicate how IBM e-business solutions have helped companies, large and small, energize their businesses by taking advantage of the Internet. Internally, the campaign is dubbed "e-culture"—because the broader intention is to tout how Internet-based solutions (with IBM boldly leading the way) have pervaded countless aspects of contemporary life.

Creative Strategy:

To profile a range of companies who've benefited in tangible ways from their Internet partnerships with IBM. Each company in the campaign has its own unique e-business solution (combinations of IBM hardware, software, design, and consulting services), so it is important that each story—though unmistakably branded as "IBM e-business"— has a feel of its own.

Marketing Placement:

By using rich media, Ogilvy tries to seduce a banner-weary audience with both playful interactivity and state-of-the-art production values—blending animation, voice, and music in ways that make "media convergence" more than a mere catch phrase. Each customer story is told with two elements: an interactive Enliven banner as a teaser, linked to a larger pop-up interstitial. Both elements are endowed with sight, sound, and motion.

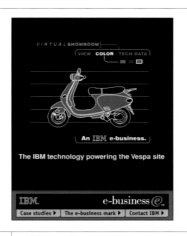
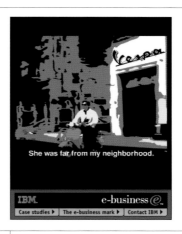
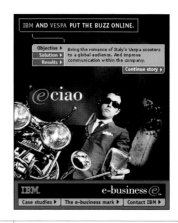

>> Once the user clicks through to the pop-up interstitial, the story is usually told in the client company's voice, via Flash animation (minimum download time) and deeper levels of detail in a testimonial case study.

>> Animation elements and styles are, again, varied according to the dictates of each customer's story.

>> For Vespa, the story is a Fellini-esque romance, in Italian with English subtitles.

>> In every case, viewers are reminded that each company "is an IBM e-business"— and gently bombarded with the curvaceous red "e" logo—in the hope that it becomes as recognizable a symbol for the Internet generation as the stolid blue "IBM" was for their parents.

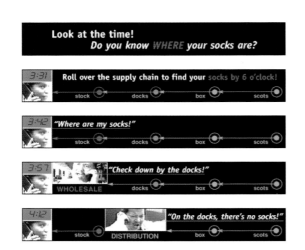

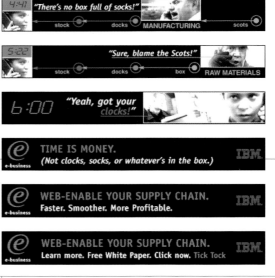

>> The imagery integrates with the corresponding IBM print and
broadcast work, while IBM's "e" logo again brands the banner space.

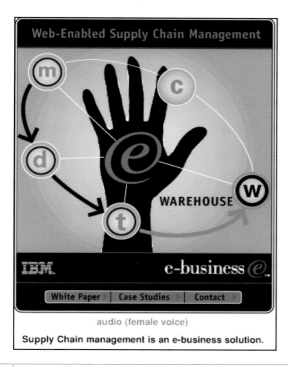

audio (female voice)

Supply Chain management is an e-business solution.

>>

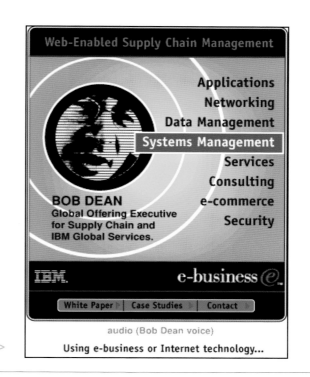

audio (Bob Dean voice)

Using e-business or Internet technology...

>> A series of Flash frames deliver the details on supply chain management.

Tools Used. MacromediaFlash / Enliven

>> Enliven allows for such enhancements as motion and sound. >>

Marketing Objective:

To gain awareness for CollegeQuest—a diverse cybertool that helps students define their "dream college" and make that dream a reality—and to encourage registration on CollegeQuest.com.

Creative Strategy:

To best communicate the many advantages of this rather complex, multi-page, multi-functioned site, OgilvyInteractive decided to offer a demonstration—right in the banner—of the Prepare/Pick/e-apply process that enables students to issue simultaneous applications to 1,000 colleges.

Media Placement:

Ogilvy uses Enliven rich-media technology to demonstrate the many useful features of CollegeQuest.com, which allows high school students to explore the entire college application process from learning how to prepare for standardized tests to investigating financial aid options and picking an actual college.

>> This banner utilizes original artwork, tailored music, and an all-important demo of the Prepare/Pick/e-apply process.

Tools Used. Enliven

>>

>> Palmer Jarvis DDB's gateway page.

>> A Flash feature celebrating the agency's 30th anniversary.

The Message Is the Message

> *Respect for the self, the client, the audience, the medium, and the message.*

> *Every disadvantage can be a potential advantage; you just have to bend the mind to shift perspectives.*

> *Don't focus on technology, focus on the message*

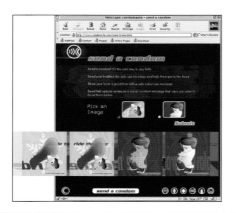

>> The online-version of the *Pacific Press* newspaper requires an energetic banner and portal to advertise its resource of hockey links within and beyond its site.

>> A youth-oriented safe-sex awareness site encourages young people to connect with each other by sending personalized messages via animated postcards from within the site.

>> Before rigid Web advertising guidelines were established by the client, this bilingual online campaign complemented outdoor and print advertising.

>> There's less creative freedom in these later samples – the layout, for example, reflects the corporate Web site.

Palmer Jarvis DDB Digital

Palmer Jarvis DDB Digital is a division of Palmer Jarvis DDB, which enjoys a solid reputation for its stellar creative. PJDDBD began in 1996 with four people crammed in one small office working on a 900-page bilingual Web site due in 16 days. Today Palmer Jarvis DDB Digital employs 15 people in three markets to develop Web initiatives for multinational, national, and regional clients.

PJDDBD's role is to think about the things its clients forget to think about, according to Roger Ferguson, national managing director at the agency. "The Internet brings potential customers to within two feet of our message. In this close proximity to who and what that message represents, they have the option to continue their visit, or to seek greener pastures. Our role is to ensure that the option of greener pastures is as remote as possible."

The Internet is a personal channel of communication driven by the user, not the marketer or publisher, although it allows for continual dialogue between all the parties. When developing an online execution, the agency tries to "become the user," Ferguson says, and "determine what is important to them." Market research plays a large role in its work, too. "Why do users care, rather than why do we think they should?" he says.

Creative director Peter Jin Hong says that he meets the challenge of the current technological restrictions placed on Web advertising by focusing on the message rather than the techology. "Ironically, the perceived caveat of technological limitations due to bandwidth considerations is forcibly beneficial in encouraging more attention to the content of the message," he says. "Marshal McLuhan popularized the argument that the medium is the message. Too often, technology has been the message. As enthusiastic as we can be about the latest technological effects, we must take care not to unwisely shift attention away from the message, compromising substance for glamor."

Design is about process, Hong says. Although there are there are no true shortcuts to good design, there are effective techniques that come with experience and humble regard for the process.

Just what is the process? "For me, it is *the* process: life," Hong says. "Too often we dissociate ourselves from the familiar and natural interactions, and try to wrestle a message that is contrived and forced. We need to reflect—or at least mimic—the subtle nuances that surround us and the lessons of communication they teach."

Hong ticks off those lessons:

- Lessons like rhythm: Tides, music, heart, and blood have natural motion; so should Web-based banner animations. If there is an animation of something that slides in and stops, it should reflect the laws of physics and nature, and recoil just a bit.
- Lessons like humor: The importance of a good laugh at least once a day.
- Lessons like respect: When we are treated with sincerity, it's noticed and appreciated.

Hong says that architects of online advertising often try too hard. "A colleague and mentor at the agency, Ron Woodall, steadfastly believes that 'we talk too much,' he continues. "Design, therefore, should not try so hard, and not say too much. We are given a privilege of being in the audience's personal space. Hence, we should be brief, entertaining, natural, and say it with sincerity."

Address.1600-777 Hornby Street, Vancouver, British Columbia Canada V6Z 2T3 / **Voice.**604 608 4451 / **Fax.**604 608 4450 / **E-mail.** vancouver.info@pjddb.com / **Web Site.**www.pjddbdigital.com / **Executives.**Roger Ferguson.National Managing Director, Peter Jin Hong.Creative Director

When you travel,

When you travel, some things can't be controlled

THE UNDER ARMS HOTEL
$2.50 surcharge for calls,
plus long distance charges.

Some things can.

>> To counter clutter and show consideration for the audience, PJDDB aims for simplicity: Lots of white space, brief but witty copy, memorable visual metaphors, animation only to accentuate a key point in the message.

No quarters?

No worries.

>> From frame to frame, there is a purposeful, rhythmic coordination to the flow and order of information, much like a strong bass beat keeps other instruments synchronized.

When you travel,

When you travel, some things can't be controlled

Some things can.

>> The client's logo inset on black is a convenient way to provide closure to the banners – and a clear call to action.

When you travel,

When you travel, some things can't be controlled

AC9 CHICAGO – VANCOUVER DELAYED
UAF CHICAGO – VANCOUVER DPT 11:15
RYL CHICAGO – VANCOUVER DPT 24:00

AC9 CHICAGO – VANCOUVER DELAYED
UAF CHICAGO – VANCOUVER DELAYED
RYL CHICAGO – VANCOUVER DELAYED

Some things can.

>> Tight management of the palette to comply with Web-safe colors, extreme control over export compression and dithering settings, and minimal change from frame to frame allow PJDDBD to maintain a 12K file size.

Creative Director.Peter Jin Hong / **Graphic Designer/Banners.**Alex Beim / **HTML Developer/Gateway.**Wendy Farrow / **Banner Optmization.**Amelia Marasa / **Copywriters.**Ian Bray, Peter Jin Hong
Tools Used.Macromedia Fireworks / Macromedia Freehand / Adobe Photoshop / Adobe Illustrator

Marketing Objective:

To promote BC TEL Calling Card campaign online, coinciding with mass media campaigns in outdoor and television, for optimum saturation and awareness and to encourage registration and usage of the card.

Creative Strategy:

Invoke the audience's interest and make them identify with imaginary situations on business trips when they might need to make a phone call.

Media Placement:

Sites that reach the 604 and 250 area codes and whose content appeals to diverse target groups.

 Wrong turn at Moose Jaw?

 Call home for directions. Get your Calling Card. Click here. **BCTEL**

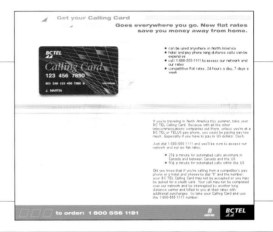

 Call 1-800-555-1111 from Canada or the US for BC TEL rates. Get your Calling Card. Click here. **BCTEL**

>> The Calling Card is positioned as an asset to the user, as well as a travel emergency necessity.

 Call 1-800-555-1111 from Canada or the US for BC TEL rates. Get your Calling Card. Click here. **BCTEL**

26

>>

Richmond Savings – Humungous Bank

>> The user scrolls past many rows of fortress-like windows on the home page before finally reaching the bank's portal with its motto: "Your money is our money."

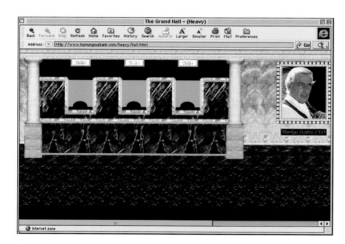 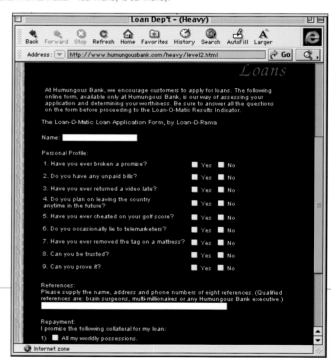

>> The teller windows are all closed and the eyes of the CEO in the portrait move left and right — the quintessential shifty-eyed businessman.

>> While the site is visually interesting, the parodies of earnest Web site copy ring true to life.

Creative Directors.Steve Vranakis, John Rich / **Graphic Developer.**John Halliday / **HTML Developer.**David Lau / **Copywrighter.**Rob Johnson
Tools Used.Macromedia Director 5 / Adobe Photoshop 4 / Adobe Illustrator 6 / Homesite 3

Marketing Objective:
To capitalize on a personality created by a newspaper and radio campaign for the fictitious Humungous Bank, which was developed for Richmond Savings to serve as a lightning rod for consumer dissatisfaction with Big Banks.

Creative Strategy:
The Web site drew in both visual and copy elements from the mainstream campaign in its execution. The attitude "Your money is our money" permeates the site.

Media Placement:
The Web site rounds out Humungous Bank's personality and presence in the market.

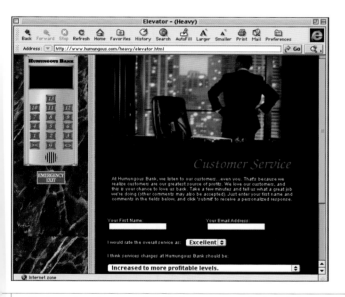

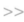

>> Shockwave elements were used to add unique segments to the site, including a mock elevator panel containing floors for various departments such as this one: Customer Service.

>> A parting shot at traditional bankers.

>> An invitation to stroll through Pixelpark to get to know its projects, people, philosophy, and approach.

>> A diverse roster of blue-chip clients.

Strategic Campaign Development

> *Successful online advertising is a synergy between visionary communications planning, superior design, and innovative success analysis.*

> *Continually measure and optimize campaign success.*

> *Use design to appeal directly to what target audiences want.*

>> With the help of situations from every day life and a lot of humor, this banner campaign illustrates that you can stay on the phone a lot longer with lower telephone costs from Callas.

>> This banner leads to the Nestlé Future Brand Investigators site (also developed by Pixelpark), where young people can develop their own food brand within an online community.

>> A banner for Allianz Insurance relates to the company's Go Future campaign. The user has to collect all the Euro coins on the banner before being "pushed" to the Web site.

Pixelpark GmbH

Founded in Berlin in 1991, Pixelpark consists of three business units: Strategic Consulting, Agency Services, and Systems and Technology. The company offers high-end, new media communication and transaction solutions. According to surveys conducted by advertising trade journals w&v and Horizont in March 1999, Pixelpark ranks as Germany's leading company in the multimedia sector. With over 270 employees (as of June 1999), Pixelpark has offices at ten locations: Berlin, Hamburg, Cologne, Stuttgart, Basle, London, New York City, Paris, Vienna, and Zurich. Its clients include a number of international corporations including adidas-Salomon AG, Allianz Gruppe Deutschland, Conrad Electronic GmbH, Deutsche Boerse AG, Deutsche Telekom AG, Habitat International, Lufthansa AG, Metro AG, Prisma Presse KoKG, Siemens AG, UBS AG, and Groupe Yves Rocher.

The perfect online shop and the optimal brand communication site don't yet exist in the Internet. Pixelpark is currently striving to create the best work the Net has seen in many small steps, all of which influence and define the media in which it works, according to Richard Maul, managing director of online advertising. Every day, technology gets better; much of what was groundbreaking yesterday soon becomes obsolete. Pixelpark is continually pushing the envelope of interactive design, trying things that it cannot know will be successful in advance.

Direct communication with users is one strength among many that makes the Internet a highly attractive marketing platform. The Net reflects the entire value chain of a company in a single channel, Maul says, and Pixelpark designs its interactive solutions to take advantage of that fact. Through online advertising, a user can be introduced to a brand, and, a few moments later, buy that product through the Internet. "This direct response is an important aspect of the medium," says Maul, "and Pixelpark designs its online advertising expressly to produce the highest direct response possible."

By evaluating click rates and purchases generated from interactive advertising, agencies can prove how successful their campaigns are. This measurability of user behavior also offers completely new possibilities for design. Pixelpark constantly tests and reworks its online advertising with the goal of creating the best solution. With the help of a tracking tool, Pixelpark analyzes banner clicks. If the click rate is too low, the banner in question is phased out or optimized. "The company that compromises in regard to design optimization establishes compromise as a standard," says Andi Henkel, the art director responsible for online advertising design. "The future of online advertising is exciting and surprising, but it is surely not a compromise."

The foundation of Pixelpark's interactive work lies in the classic rules of design. The Internet offers new and different possibilities as a medium, but that doesn't mean that all previous guidelines are invalid, Henkel says. Typography, colors, and traditional studies concerning how viewers interpret design are respected and developed to meet the infinite possibilities for interplay between text, images, sound, animation, interaction, and reaction in new media. Design at Pixelpark is not a matter of taste, but the creation of an interface between human beings and technology that focuses entirely on the user.

"We understand that the person who clicks on a misleading banner, or who cannot find their orientation on a Web site, will become angry and leave," Henkel says. "Therefore, the ultimate success of an online advertising campaign depends on designing with the user foremost in mind."

Every day, new rules for the Internet are discovered and old ones discarded. Realizing this dynamic, Pixelpark redefines itself every day — learning from experience and attempting to design the future the best it can.

>> The campaign illustrates the diverse Quoka product offerings in a straightforward manner.

>> Barmer, the largest health insurance company in Germany, extends its customer service onto the Web.

>> Users follow the footsteps of a polar bear from the Langnese ice cream print campaign through the banner and onto the Web site.

Affiliated with Bertelsman AG / **Address.**Reuchlinstr. 10-11 D-10553, Berlin Germany / **Voice.**+49 30 349 81 500 / **Fax.**+49 30 349 81 400 / **E-mail.**info@pixelpark.com / **Web Site.**www.pixelpark.com / **Executives.**Paulus Neef.Founder, President & CEO, Dr. Christian Jarchow.Director Online Advertising and Marketing Research, Richard Maul.Managing Director Online Advertising, Florian Dengle.Creative Director International, Andi Henkel.Art Director

>> The design clearly illustrates why users should come to the Conrad site and what will await them.

>> The Conrad banner campaign was optimized at various stages until it directly addressed the target audience. The average click rate for banners in Germany is 0.6 percent; the average click rate for Conrad banners is 2.0 percent.

>> Pixelpark achieved a high recognition effect by relating the visuals in the online banners to those in the successful print campaign.

Concept Development/Screen Design.Annette Fricker / **Project Management.**Richard Maul/ **Media Planning.**Antje Quellmalz / **Concept Development/Art Direction.**Andi Henkel
Tools Used.Adobe Photoshop / Macromedia Fireworks

Marketing Objective:
Establish brand recognition for Conrad Electronic GmbH on the Internet, attract new users and specialized sellers to Conrad's site, and sell more Conrad products.

Creative Strategy:
Based on Conrad's advertising campaign in traditional media, the creative concept plays with the diversity of its products and how easily accessible they are. The design communicates the core idea that users don't need to search for products in one of Europe's largest online stores because they simply will find them.

Media Placement:
The banners for brand recognition through product diversity appear on often-used, general interest sites (search engines, portals, etc.), while banners to attract sellers and buyers in specialized product categories appear on sites geared toward specific target audiences (bargain marketplaces, classified ad marketplaces).

>> This microsite shows a car radio available from the online shopping world of Conrad. As long as the user is online, he or she can keep the window open and listen to various Internet radio stations.

 Innovation **is** **When We Teach Your Factory**

>> This banner from the first stage of the campaign is strongly based on the print
campaign and is designed to generate maximum brand recognition.

 how to Think. **Innovation**
Siemens. The Power of Invention.

HES **Siemens macht dicht!**

Yeaaaah Der perfekte Lauschangriff

 Rätselhaft: Immer mehr Autofahrer ohne Schlüss

>> These three banner designs were put to a detailed user test to see which illustrative approach was most effective:
the initial design, a typographic direction, or a comic approach.

Project Management. Anja Kantowsky, Helga Beck / **Creative Director.** Florian Dengler / **Art Directors.** Martin Steinacker, Christof Ulbrich / **Graphic Design.** Christine Franke, Annette Wuensche /
Concept Development and Text. Maria Grotenhoff
Tools Used. Adobe Photoshop / Macromedia Fireworks

Marketing Objective:

The online campaign consists of a series of more than 30 banners and a microsite, which serve to create awareness of Siemens AG as an innovative leader in the high-tech marketplace. The interactive banners are only one part of a multi-platform campaign that includes print advertisements, billboards, and a traveling exhibit in which Siemens innovations are explained and demonstrated.

Creative Strategy:

The banners are designed to illustrate highly complex technical innovations in a straightforward, easy-to-understand way. The diverse designs also showcase the variety of Siemens innovations.

Media Placement:

Pixelpark adapted the online advertising campaign over time: The first banners were placed on general interest and business sites to maximize page views and brand recognition among the general public and investors, while later banners were featured on scientific sites to maximize click rates.

>> It turned out that the typographic approach was clicked most often, so Pixelpark optimized the campaign based on that approach.

>> This is the microsite, which opens when a user clicks on a banner. Each image in the scrolling bar at the bottom relates to one banner. When clicked, it provides more information about the product at hand — in this case the traffic control system MOTION, which is not only explained, but can also be experienced interactively in a product demo.

>> sinner+schrader offers a full spectrum of services to plan, realize, and market online services to an array of clients from market leaders to start-ups.

Interactivating Business

> *Building a brand means that the consumer should recognize you at a single glance.*

> *Design is to a Web site what fashion is to people: Depending on your situation, it has to make you look great, but sometimes it just has to protect you against the rain.*

> *Combine clear design with innovative technology. It sells!*

sinner+schrader interactive marketing

One of the leading German multimedia agencies, sinner+schrader has doubled in size annually since its founding in 1996 and now employs more than 100 people from all over the world. It is a full-service agency that focuses on delivering products and services through the Internet for market leaders such as Deutsche Bank AG, Hewlett-Packard, and Europcar car rental, as well as for startup companies like Transtec and Softline.

"We combine clear design with innovative technology," says art director Chanthasene Sananikone. "We do not want users to be amazed by our design, but to buy our products and services."

From a North American perspective, the German Internet market may seem small and underdeveloped, points out Ralf Scharnhorst, head of media at sinner+schrader. User figures and advertising revenue clearly lag behind the U.S., and almost every successful American site is translated into some European languages. But sinner+schrader deeply believes that the European market has its own rules, and it concentrates on developing e-commerce applications for companies operating there. In addition, each country in Europe has its own nuances. Germany, for example, regulates the use of databases that contain personal information.

Marketers are not in a good position to adapt their strategies into an e-business model until they have analyzed consumer behavior in their markets, according to Scharnhorst. The goal is to win consumer loyalty. New technologies or plug-ins should not be implemented just because they are possible. "New ideas," Scharnhorst warns, "should always focus on the benefit for the customer."

>> The product is the hero in these "personality" banners that create interest for specific auctions at ricardo.de.

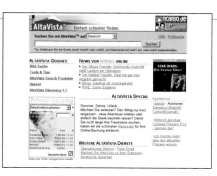

>> This HTML insert (lower left) for Deutsche Bank displays important market rates with a 15-minute delay, as well as the ability to click-through for specific stock quotes and information.

>> A banner for Europcar pops up in the middle of the page on Fireball.de.

>> On the top right, an ad for Unicum offers a Nokia mobile phone for $25 U.S. and a D2 provider contract. Two other phones are offered in the HTML selector.

15 16 17 18 19 20 21 22 23 24 25 26 27 **28**

Address.Planckstrasse 13 22765, Hamburg, Germany / **Voice.**+49 40 39 88 55-0 / **Fax.**+49 40 39 88 55 55 / **E-mail.**info@sinner-schrader.de /
Web Site.www.sinner-schrader.de / **Executives.** Oliver Sinner.Geschäftsführer, Matthias Schrader.Geschäftsführer, Chanthasene Sananikone.Art Director

>>

ricardo.de

>> These simple GIF banners establish awareness for the ricardo.de brand as the first German online auction service.

>> Promising fun and entertainment in an effort to make the brand likeable, a series of banners feature a broad variety of smiling faces that ask questions such as, "Online auctions, what's that?"

>> Actual auction text is saved as ASCII text on the server; the messages are sent every 10 seconds to the banner to highlight the fact that ricardo.de features real auctioneers.

Art Director.Chanthasene Sananikone / **Designers.**Nis Niemeier, Sascha Milenovich, Gunnar Winter
Tools Used.Adobe Photoshop / GIF Wizard / Macromedia Flash / Homesite

Marketing Objective:

Generating brand awareness for "ricardo.de The Auction Channel" and creating interest for specific auctions.

Creative Strategy:

Different approaches are used to achieve different goals. For example, the feeling of live auctions is achieved through Flash banners; simple GIFs carry the brand name. The personality banners create interest for specific auctions.

Media Placement:

Depends on the goals of the various phases of the campaign, ranging from buys on a wide range of sites to diversify reach, to keyword buys on search engines to display specific product categories.

>> Due to the successful branding campaigns, ricardo.de attracted 300,000 registered users in its first
year—about three percent of Germany's Internet community.

>> Comparable to a chat, the users place
their bids as the auctioneer praises the
product's features.

>> A search for the keyword "Hemingway" on web.de displays Libri.de text advertising "books related to 'Hemingway' (234 titles await the user who clicks through), as well as a Libri.de button boasting "one million books and videos."

>> There is little space left for creativity on this search page on Libri.de. In addition to the text "books related to Hemingway," sinner+schrader established the button with the Libri.de brand logo.

>> The HTML-banner allows you to type a search for a book or author directly into the banner. The colors are taken from the Libri.de corporate identity and the books and arrows are animated.

>> Observations with eye-tracking tools showed that the rules for banner advertising were the same as in print advertising: most users read from top left to bottom right. As a result, the position of the search box was switched from the first execution. Click rates declined, though, probably because of the decrease in colors.

Art Director.Chanthasene Sananikone / **Designers.**Nis Niemeier, Sascha Milenovich,Gunnar Winter
Tools Used.Adobe Photoshop / GIFwizard / Macromedia Flash / Homesite

Marketing Objective:

Libri.de is an online bookstore run by a wholesaler that either mails books to customers or ships them for 24-hour pick-up at local stores. It is crucial for Libri.de to keep track of customers who frequently order expensive books, as opposed to those who order occasional paperbacks. sinner+schrader's Adtraction ad tracking tool not only shows the cost per order for each Web site but also splits up the statistics into new customers and those already registered.

Creative Strategy:

Creativity is not as important as communicating reliability and ease-of-use. Market research shows users do not want advertising—they want service.

Media Placement:

In the beginning, the strategy for Libri.de focused on long-term contracts with high traffic-sites, such as the German portal site web.de, to generate a high reach quickly. Later banners were targeted to specific special-interest sites.

>> The "hammock" theme targets people heading for holiday who visit a tourism and travel site; the text reads,"...and now let's read a good book."

>> "Hardcover instead of hardcore" ran on nerve.de and got click-throughs as high as 35 percent. Since Libri.de didn't actually offer the desired erotic entertainment, however, the cost per order rates were disastrous and only improved when it started offering XXX videos.

15 16 17 18 19 20 21 22 23 24 25 26 27 28

Directory

APL Digital Sydney / Level 7, 65 Berry Street, North Sydney NSW 2060, Australia / **Voice.**+61 2 9925 1333 / **Fax.**+61 2 9954 3055 / **E-mail.**contact@apldigital.com.au / **Web site.**apldigital.com.au

Beyond Interactive / 5075 Venture Drive, Suite B, Ann Arbor, MI 48108 / **Voice.**734-747-8619 / **Web site.**http://www.gobeyond.com / **E-mail.**manager@gobeyond.com

Brand Dialogue / Y&R Worldwide / Frans van Mierisstraat, 1071 RZ Amsterdam, The Netherlands / **Voice.**+ 31 20 570 64 84 / **Fax.**+31 20 675 78 70 / **E-mail.**info@brand-dialogue.nl / **Web site.**www.brand-dialogue.nl

Brand Internet /Satama Interactive / Birger Jarlsgatan 18D, 114 85 Stockholm, Sweden / **Voice.**+46 8 506 124 10 / **Fax.**+46 8 506 124 39 / **E-mail.**info@brandinternet.com / **Web site.**www.brandinternet.com

Carton Donofrio Interactive / 120 West Fayette Street, Baltimore, MD 21201 / **Voice.**410 576 9000 / **Fax.**410 752 2191 / **E-mail.**sean@cdinteractive.com / **Web site.**www.cdinteractive.com

Connectworld / 52 Rue de Dunkerque, 75009 Paris, France / **Voice.**+33 1 5602 2222 / **Fax.**+33 1 5602 2223 / **E-mail.**contact@connectworld.fr / **Web site.**www.connectworld.fr

Darwin Digital / 375 Hudson Street, New York, NY 10014 / **Voice.**212 807 3700 / **Fax.**212 807 3725 / **E-mail.**contact@darwindigital.com / **Web site.**www.darwindigital.com

eyescream interactive / 17650 NW Gilbert Lane, Portland, OR 97229 / **Voice.**503 292 6987 / **Fax.**503 296 0945 / **E-mail.**info@eyescream.com / **Web site.**www.eyescream.com

Freestyle Interactive / 58 2nd St., San Francisco, CA 94105 / **Voice.**1 800 460 3693 / **E-mail.**sales@freestyleinteractive.com / **Web site.**www.freestyleinteractive.com

i33 communications / 15 West 26th Street, 9th Floor, New York, NY 10010 / **Voice.**212 448 0333 / **Fax.**212 481 7909 / **E-mail.**david@i33.com / **Web site.**www.i33.com

iDeutsch / 111 Eighth Ave., 14th Floor, New York, NY 10011 / **Voice.**212 981 7600 / **Fax.**212 981 7537 / **E-mail.**adam_levine@ideutsch.com / **Web site.**www.interactivedeutsch.com

i-frontier / 1241 Carpenter Street, Philadelphia, PA 19147 / **Voice.**215 755 -2250 / **Fax.**215 755 2630 / **E-mail.**info@i-frontier.com / **Web site.**www.i-frontier.com

i-traffic / 375 West Broadway, New York, NY 10012 / **Voice.**212 219 0050 / **Web site.**www.i-traffic.com / **E-mail.**info@i-traffic.com

K2 Design, Inc. / 30 Broad Street, 16th Floor, New York, NY 10004 / **Voice.**212 301 8800 / **Fax.**212 301 8801 / **E-mail.**info@k2design.com / **Website.**www.k2design.com

Kabel New Media / Schulterblatt 58, 20357 Hamburg, Germany / **Voice.**+49 432 969 0 / **Fax.**+49 432 969 90 / **E-mail.**info@kabel.de / **Web site.**www.kabel.de

kirshenbaum bond & partners / 145 6th Ave., New York, NY 10013 / **Phone.**212-633-0080 / **Fax.**212 463 8643 / **Web site.**www.kb.com

LDV BATES / Hangar 26, Rijnkaai 26-27, B- 2000 Antwerp, Belgium / **Voice.**+32 3 2292929 / **Fax.**+32 3 2292930 / **E-mail.**ldvbates@ldvbates.be / **Web site.**www.ldvbates.be

Left Field / 945 Front Street, San Francisco, CA 94111 / **Voice.**415 733 0700 / **Fax.**415 733 0701 / **E-mail.**leftfield@leftfield.net / **Web site.**www.leftfield.net

Leo Burnett Interaktiv / Drammensveien 120, 0277 Oslo, Norway / **Voice.**+4722926800 / **Fax.**+4722926944 / **E-mail.**camilla.kristiansen@leoburnett.no / **Web site.**www.leoburnett.no

Lot21 Interactive Advertising / 548 Fourth Street, San Francisco, CA 94103 / **Voice.**415 227 2121 / **Fax.**415 227 2138 / **E-mail.**mollyp@lot21.com / **Web site.**www.lot21.com

M2K / 313 South Congress, Suite 200, Austin, TX 78704 / **Voice.**512 448 7791 / **Fax.**512 448 7769 / **E-mail.**rmcewen@m2k.com / **Web site.**www.m2k.com

Manne & Co. / Kungsgatan 48, 111 35 Stockholm, Sweden / **Voice.**+ 46 8 20 60 31 / **Fax.**+ 46 8 21 03 25 / **E-mail.**direct@manneco.se / **Web site.**www.manne.nu

Modem Media.Poppe Tyson / **Voice.**203 299 7000 / **Fax.**203 299 7461 / **E-mail.**rallen@modempoppe.com / **Web site.**www.modempoppe.com

MVLG e-business consultants / De Lairessestraat 156, 1075 HL Amsterdam, The Netherlands / **Voice.**+31 0 20 570 35 35 / **Fax.**+31 0 20 671 72 49 / **E-mail.**ebusiness@mvlg.com / **Web site.**www.mvlg.com

OgilvyInteractive Worldwide / 309 West 49th Street, New York, NY 10019 / **Voice.**212 237 6000 / **Fax.**212 237 5123 / **E-mail.**maryfichter@ogilvy.com / **Web site.**www.ogilvyone.com

Palmer Jarvis DDB Digital / 1600-777 Hornby Street, Vancouver, British Columbia, Canada V6Z 2T3 / **Voice.** 604 608 4451 / **Fax.** 604 608 4450 / **E-mail.**vancouver.info@pjddb.com / **Web site.**www.pjddbdigital.com

Pixelpark GmbH / Reuchlinstrasse 10-11, D-10553 Berlin, Germany / **Voice.**+49 30 349 81 500 / **Fax.**+49 30 349 81 400 / **E-mail.**info@pixelpark.com / **Web site.**www.pixelpark.com

sinner+schrader interactive marketing / Planckstrasse 13, 22765 Hamburg, Germany / **Voice.**+49 40 39 88 55 0 / **Fax.**+49 40 39 88 55 55 / **E-mail.**info@sinner-schrader.de / **Web site.**www.sinner-schrader.de

Index

Acknowledgments

This book would not have been possible without the commitment of dozens of people who believe in the value of their agency's work and were willing to invest some time toward the future of Web advertising. For their contributions as catalysts, coordinators, writers, designers, executives, and evangelists for their respective agencies, I'd particularly like to thank:

Ian Stromsmoe and Laura Peck (APL Digital Sydney)

Helga Beck (Pixelpark GmbH)

Meredith Sharp (Beyond Interactive)

Stacy Perchem and Teresa Julien (Darwin Digital)

Stefanie Kuller (i33 communications)

Molly Parsley (Lot21 Interactive Advertising)

Hillary Benjamin (kirshenbaum, bond & partners)

Fred Schwartz (Left Field)

Rand Ragosa (Freestyle Interactive)

Diane MacMillan (M2K)

Kalle Haasum and Erik Haglf (Manne & Co.)

Camilla Kristiansen (Leo Burnett Interaktiv)

Erwin Jansen and Sofie Pintens (LDV BATES)

Pija Sundin (Brand Internet)

Cynthia Fuhrman (eyescream interactive)

Rebecca Marks and Vincent Albers (Brand Dialogue)

Sean Carton and Brian J. Lewbart (Carton Donofrio Interactive)

Flora Bernard and Randall Koral (Connectworld)

Garrett Glaser (iDeutsch)

Roger Ferguson (Palmer Jarvis DDB Digital)

Tom Hespos and Douglas Cleek (K2 Design)

Brad Aronson and Jeremy Lockhorn (i-frontier)

Myles Weissleder (i-traffic)

Tina Kulow (Kabel New Media)

Bas Verhart (MVLG e-business consultants)

Len Stein (OgilvyInteractive Worldwide)

Ralf Schornhorst (sinner+schrader interactive marketing)

I had a lot of help in identifying potential contributors to the book, particularly agencies outside the United States. Many thanks for the leads to:

Wenda Harris Millard, Barry Salzman, Jennifer Franchetti, Jan Gronbech, Stephane Cordier, Nicholas Reggiano, Goran Arvinius, Scott Knoll, Wendy Muller, Arno Otto, and their colleagues at DoubleClick, whose extensive knowledge of global interactive advertising trends proved invaluable.

Alan Penchansky of The Pen Group, a PR pro who does things the way they should be done.

Matt Thornhill, president of Loose Gravel Advertising and one of the first traditional agency guys to "get it."

Jonathan Ewert of Modem Media. Poppe Tyson, who went beyond the call of duty on behalf of his agency.

Shai Desai, senior analyst at www.consult.com.au, the leading Australian-based Internet research and consulting group.

Kate Rapson at Graham Associates, who made lemonade out of a lemon.

Finally, several people helped me conceptualize, gather, edit, and tweak the copy and art. My undying gratitude to:

Glenn Fleishman, an Internet marketing pioneer who's about 15 years younger and 15 percent wiser than I, and who suggested that I write the book.

Shawna Mullen, who acquired the book for Rockport Publishers, guided it through the early planning, then moved on to a well-deserved promotion.

D. Jackson Savage of Carriage House publishing who seamlessly picked up the project and graciously saw it through completion.

Cathy Kelley, who oversaw a talented design team and made us all look good.

Sue Ducharme, whose copyediting made the words read the way I wished I'd originally written them.

Sharon O'Shea, whose editorial and professional assistance lining up the European agencies was invaluable.

Andrew Jaffe, a former comrade in the trenches of journalism, who without hesitation agreed to write a thought-provoking Foreword.

Most of all I want to thank Deirdre, Carrick, and Duncan. I'm here because you're there, and your love and support keep me going.